Art Deco Textile Designs

Tina Skinner

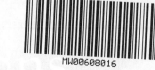

Schiffer Publishing Ltd

4880 Lower Valley Rd. Atglen, PA 19310 USA

Acknowledgments

To Tammy Ward for
her fast and hard work

Copyright © 1998 by Schiffer Publishing Ltd.
Library of Congress Catalog Card Number: 98-85122

Designed by Bonnie M. Hensley
Typeset in Bernhard Modern BT (Bold)/Zapf Humanist 601 BT

ISBN: 0-7643-0650-2
Printed in China

Published by Schiffer Publishing Ltd.
4880 Lower Valley Road
Atglen, PA 19310
Phone: (610) 593-1777; Fax: (610) 593-2002
E-mail: Schifferbk@aol.com
Please write for a free catalog.
This book may be purchased from the publisher.
Please include $3.95 for shipping.

In Europe, Schiffer books are distributed by
Bushwood Books
6 Marksbury Avenue
Kew Gardens
Surrey TW9 3BQ England
Phone: 44 (0)181 392-8585; Fax: 44 (0)181 392-9876
E-mail: Bushwd@aol.com

Please try your bookstore first.
We are interested in hearing from authors
with book ideas on related subjects.

Contents

Introduction ..**4**

Exotic Influences
 Asian ..5
 Mayan/Aztec ..15
 Middle Eastern ..21
 Indian ..31

Floral ..**37**

Geometric ..**74**

Abstract ..**84**

Bibliography ..**112**

Introduction

The term "Art Deco" was actually coined long after it first emerged in post-World War I France, during its reemergence in the 1960s. In its own day, Art Deco was referred to as "Moderne" or "Modernistic." These terms more accurately depict the mood of the moment, of a time when industrialization was reshaping the world and people believed they had left war behind them, opening up a future of growth and invention.

The Western world got a goodly dose of Art Deco, an art form created for the masses, as the century roared ahead in the 1920s. It was applied largely in advertising, though its legacy is most prominent in the more solid manifestations of this creative period—architecture. As it became assimilated into American culture, the style became known as "Jazz Moderne" and, reflecting American's fascination with higher and higher skyscrapers, it was eventually known as "New York Style." The world was drunk on modern living, speed, and utility. Emily Burbank, a dancer and prominent socialite, called the 1920s "our Age of Utility."

Post-fact, the term Art Deco was drawn from the 1925 *Paris Exposition Internationale de Arts Décoratifs et Industriels Modernes*. The expo targeted a new move toward mass-oriented production, and away from the elitist phase preceding the war. Art and industry were merging. Moreover, industry's promoters, the advertising people, were discovering art's ability to penetrate the subconscious. Art, they found, could lend an aura to a product. And the aura they sought was that of modernity, of progress, of speed.

The new style presented to the world at the exposition is primarily credited to the Bauhaus collective. Founded by Walter Gropius in 1919, the group created bold new models for industry and housing based on functional designs and Spartan simplicity. Americans returned from the expo on fire with new design ideas, and Gropius, too, made his way to the United States, becoming chairman of the Graduate School of Design at Harvard.

Predating Bauhaus, French cubism in post-World War I France was largely influential in the Art Deco movement. One of the biggest innovators in this field was Paul Poiret, who founded the first modern design academy, *L'Ecole Martine*, in 1911 and introduced cubist trends in fashion.

Another big movement was almost antithetical to the futuristic mood of the moment—a fascination with extinct cultures. The ancient Egyptian king Tutankhamen's tomb was opened in 1922, capturing the world's imagination; the fascination with ancient cultures also encompassed the Aztec, Mayan, Assyrian, and Byzantium. Léon Bakst combined these, along with Oriental influences, in his scenery and costumes for the Ballets Russes, helping to spark designers' imaginations. In addition, as jazz and its African-American roots were explored on both sides of the Atlantic, African tribal designs found their way into the modern mix.

The patterns in this book represent these influences as they filtered down to the public. Designed primarily for simple cotton fabrics, these were the textiles of everyday wear and home decoration during the 1920s and '30s, primarily during the summer. Fashion icons such as Burbank still espoused the standard black and greens for winter and fall, but were begging for more color—more exotic colors—in the warmer seasons.

In a guide to women's fashions written in 1938, Margaret Byers advised women to forget about the old "blue for a blonde, and pink for a brunette" maxim. "Beginning with Egypt, we note a fondness for terracottas, saffrons, and turquoises . . . Now look at Chinese art. Ming yellow and Chinese red. . ." Byers suggested a number of additions to women's style palettes—chartreuse, green, golden brown, violet, rose beige, scarlet, and peach—colors that are likewise prominent in this volume.

The newly prominent Art Deco patterns and exotic colors were being applied to clothing that was increasingly pared down. "The outstanding characteristics of woman's dress to-day, in Paris, London and New York, are simplicity—the elimination of unnecessary outline and detail," Burbank wrote.

Society was rebelling against the elaborate ornamentation of the Belle Époque and Art Nouveau, racing toward a more modern, multi-cultured future.

These photographs of historic fabric samples from the mid-1920s and '30s are presented here to spark the imaginations of textile and fashion designers and continue the quest for modernity and cultural exploration.

Exotic Influences

Asian

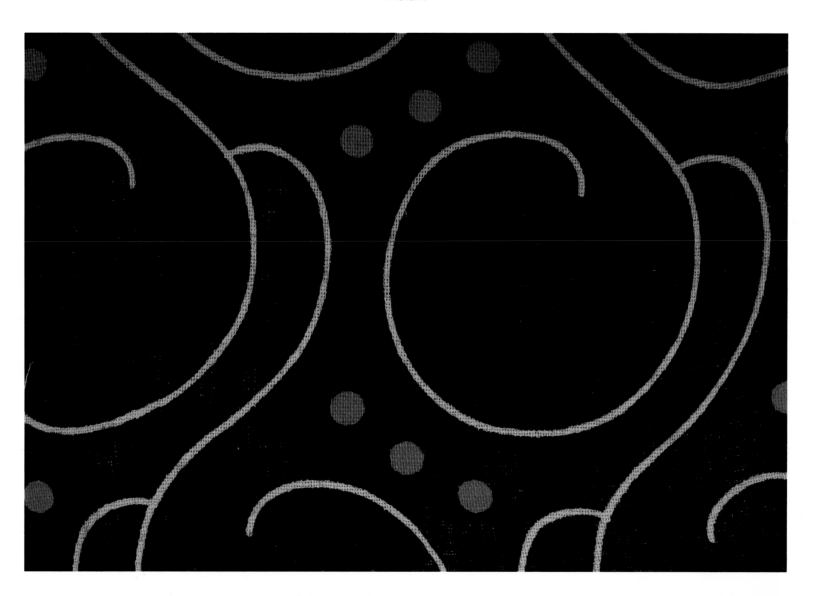

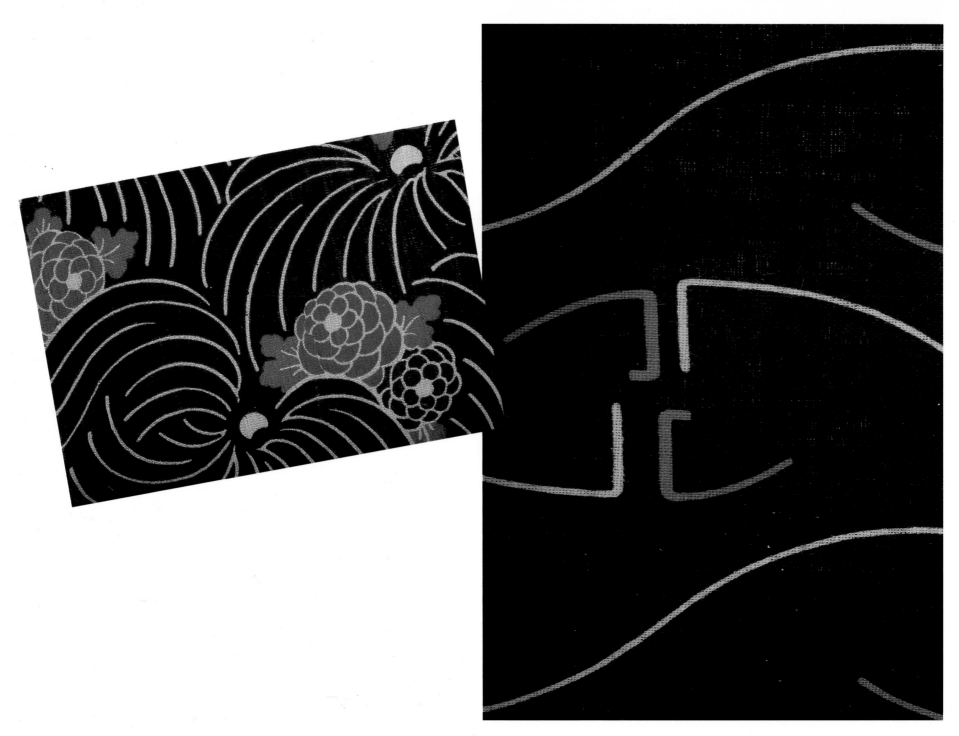

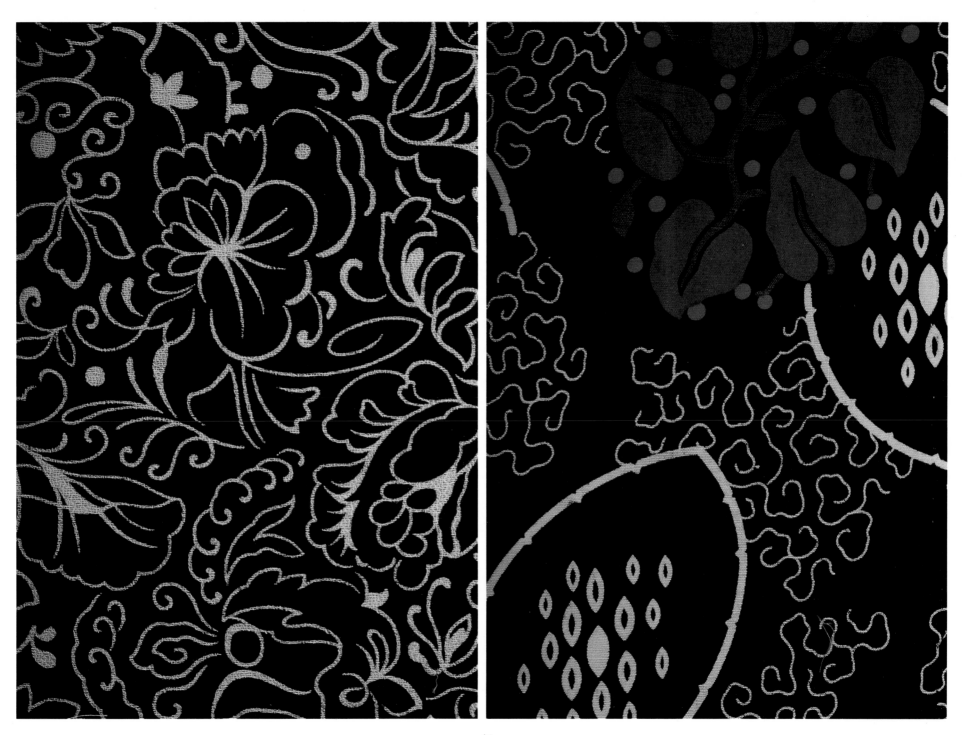

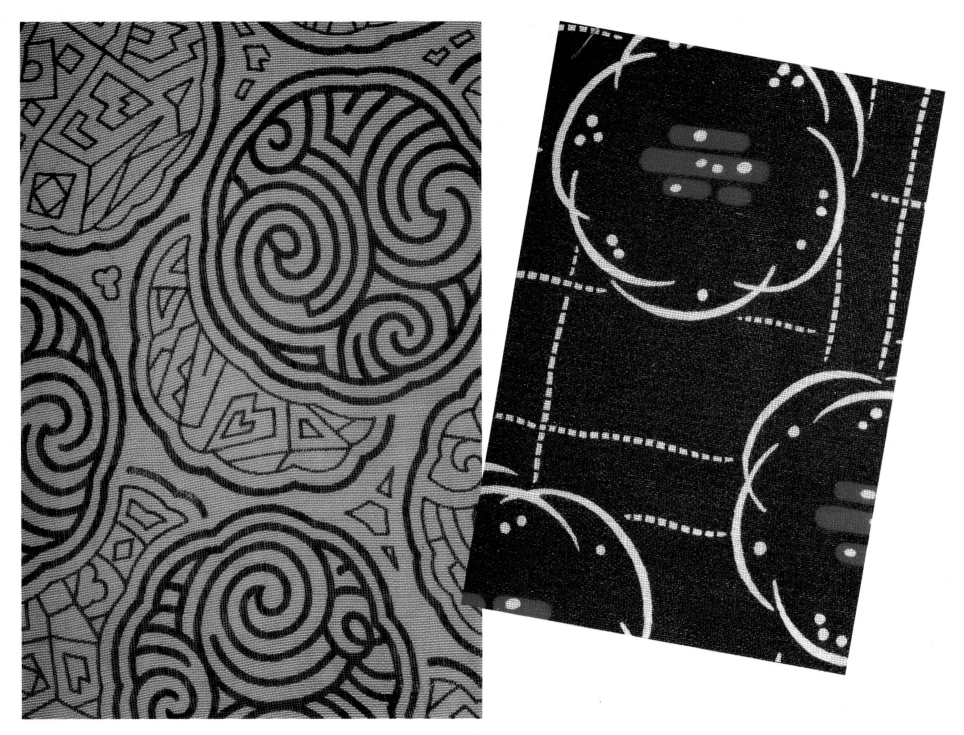

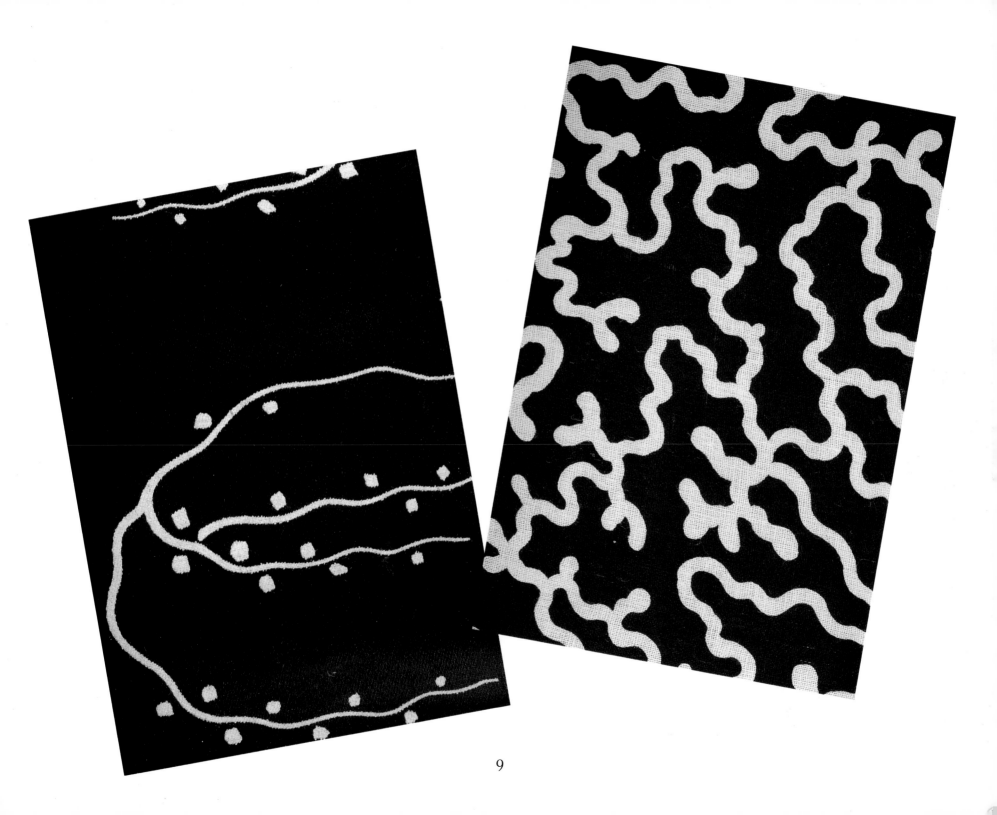

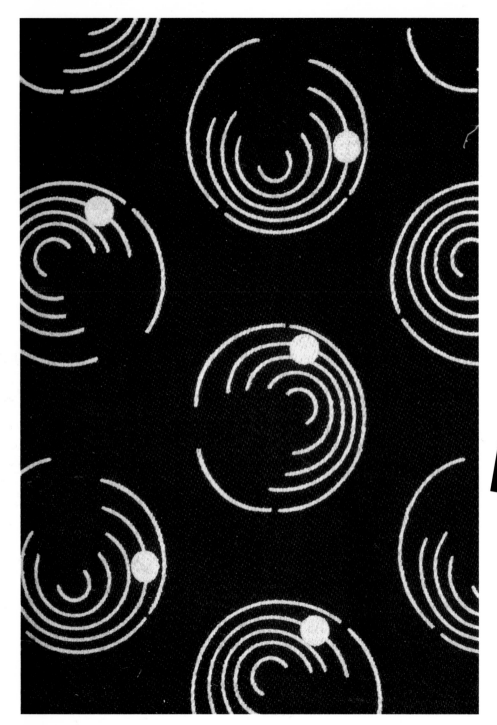

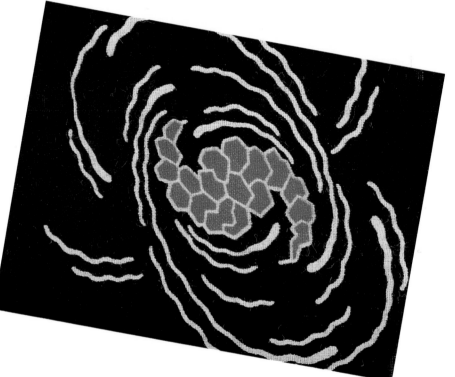

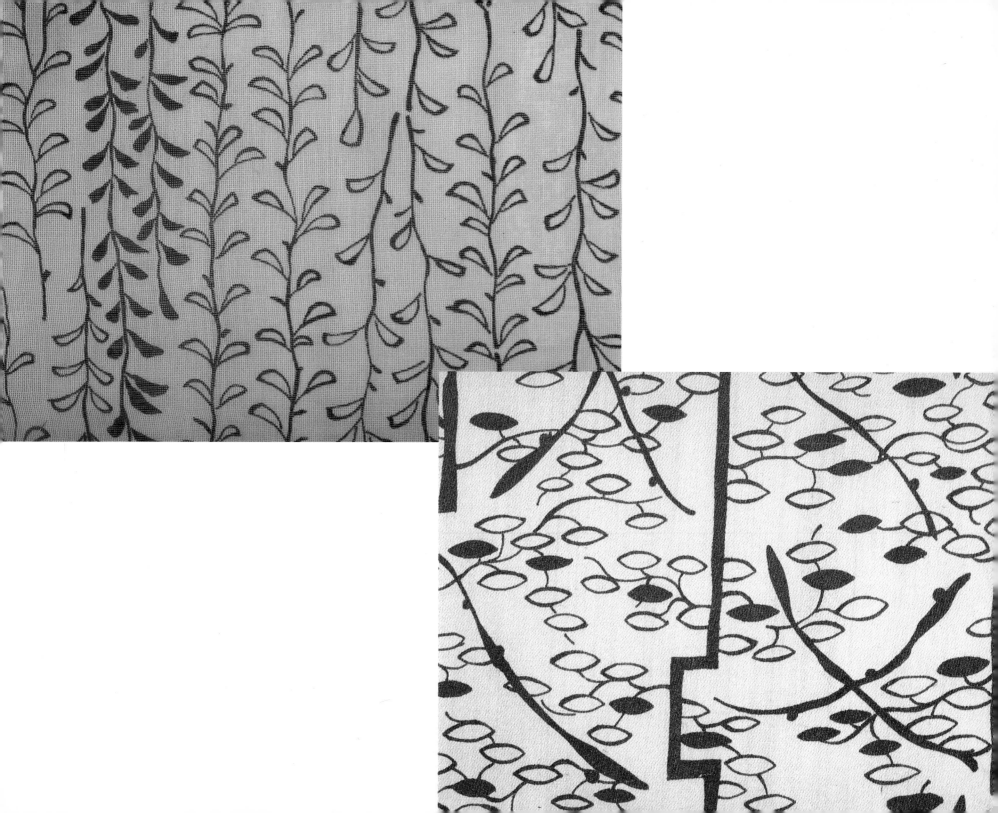

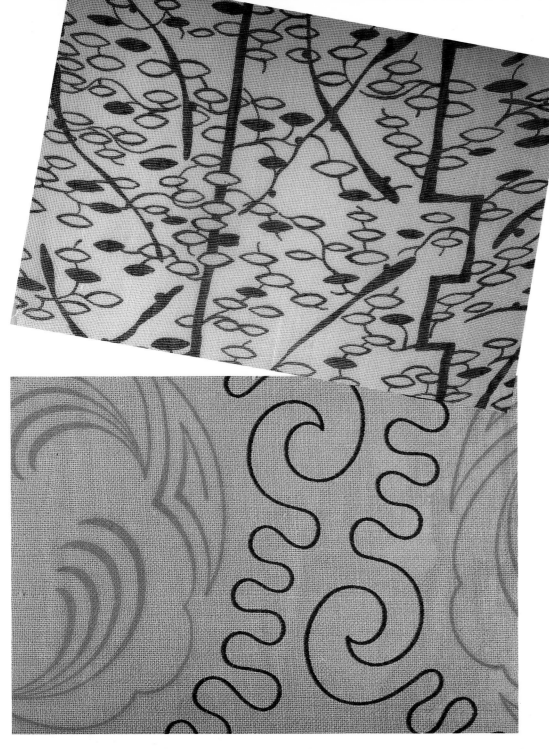
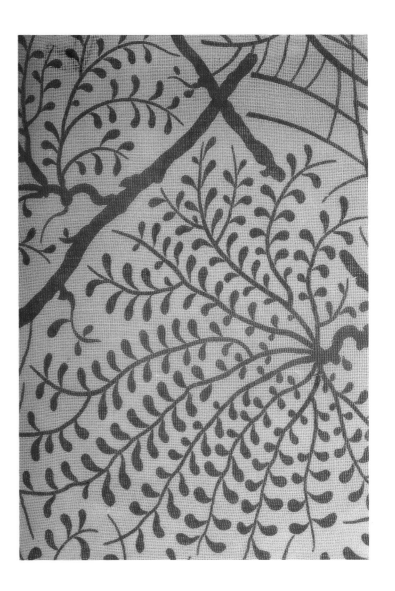

12

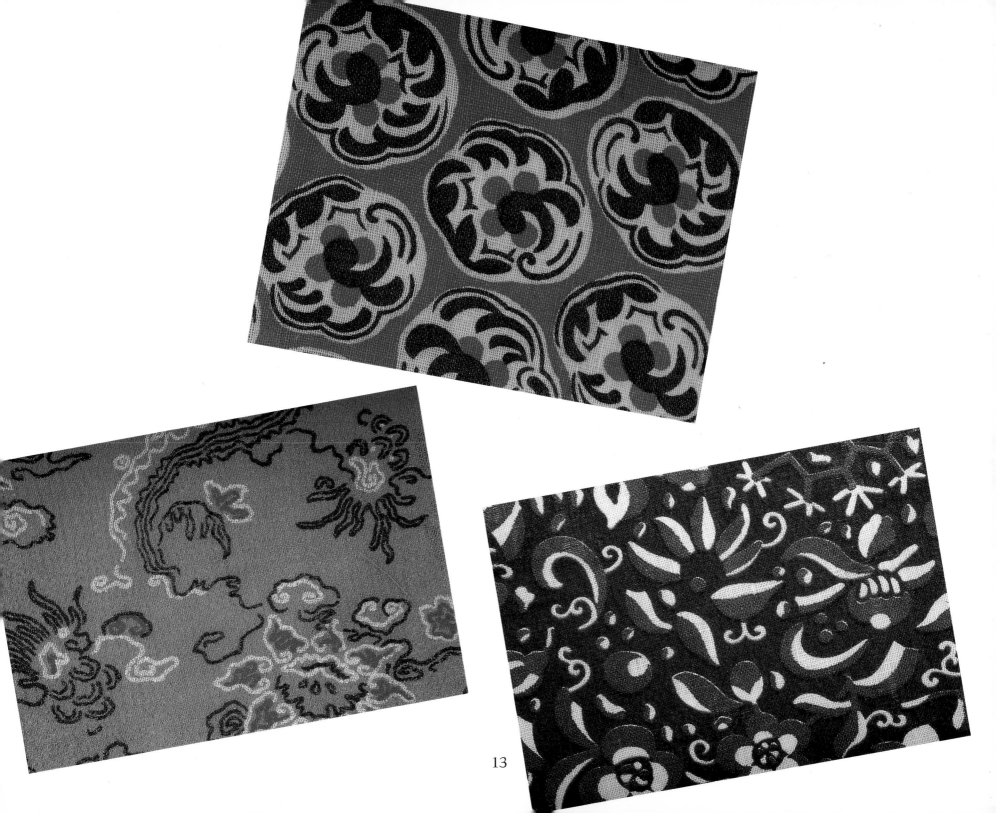

13

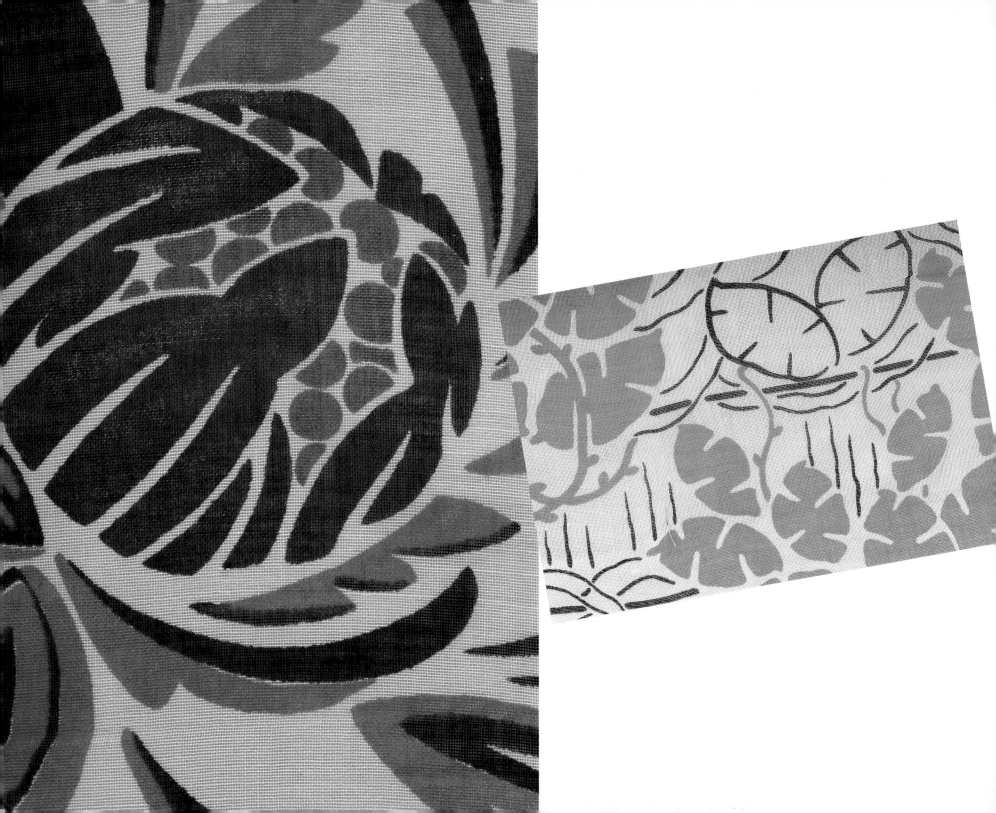

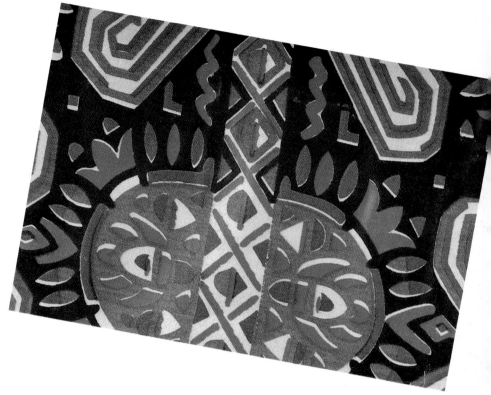

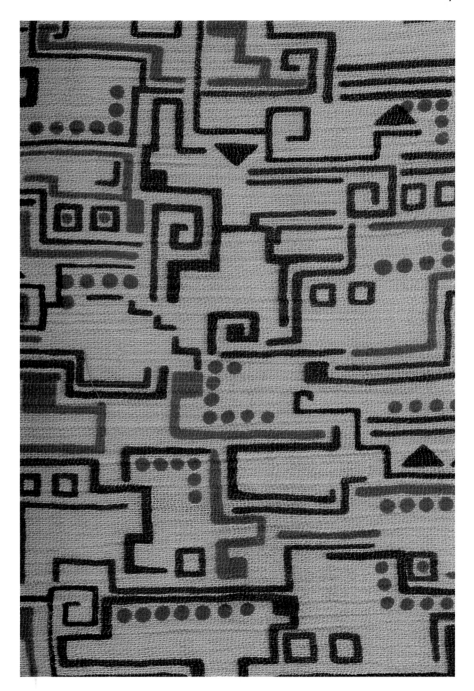

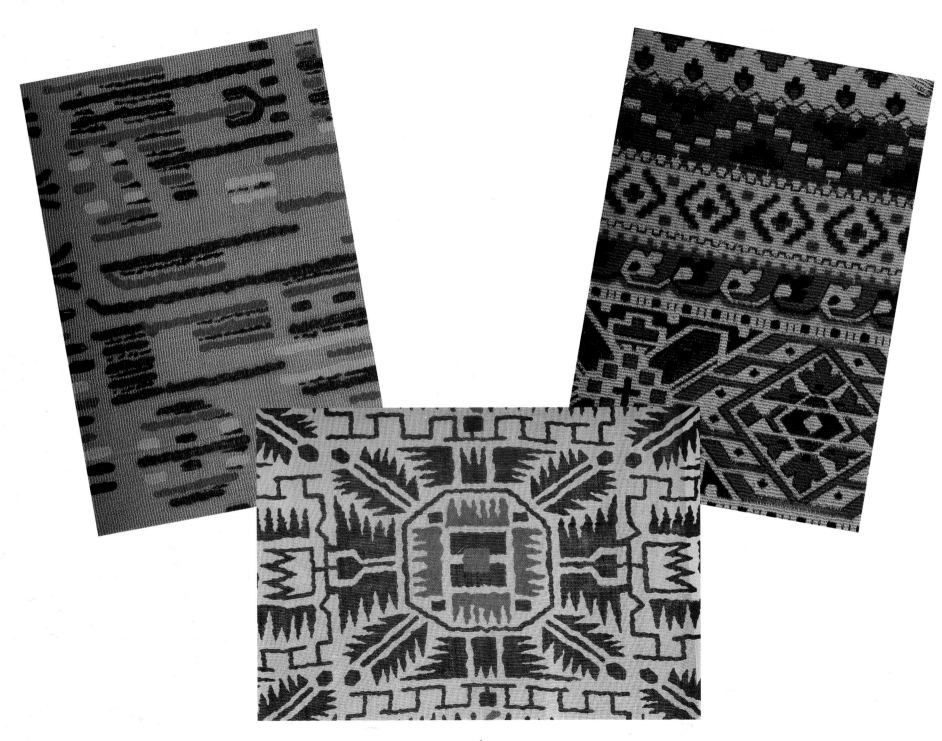

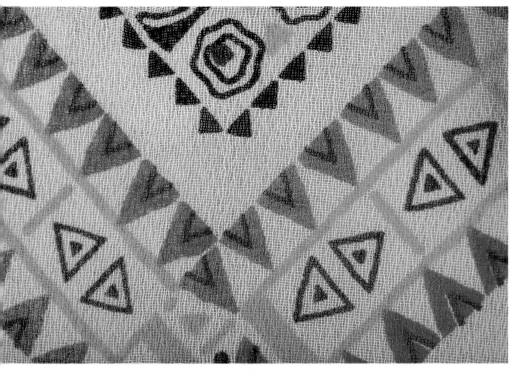
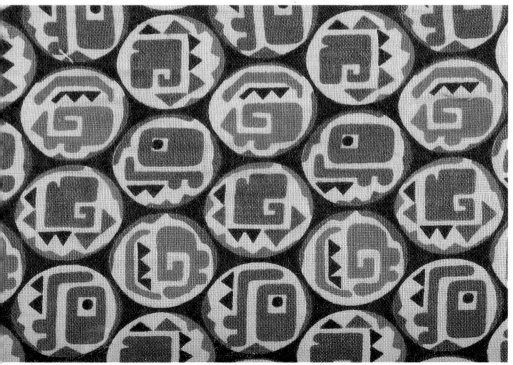
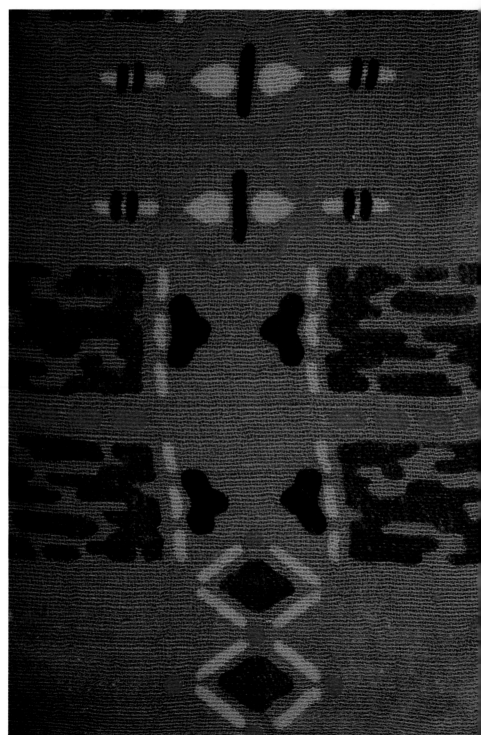

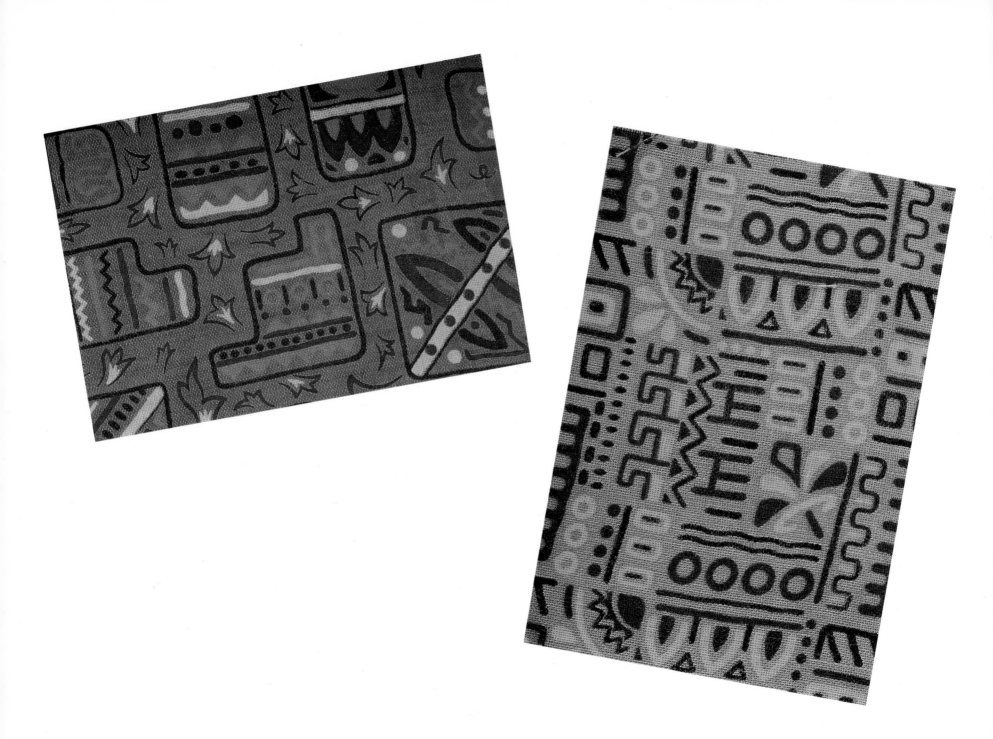

18

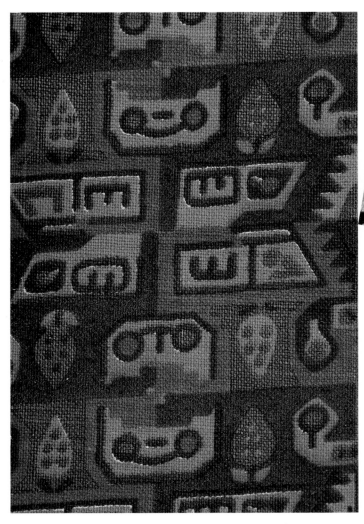
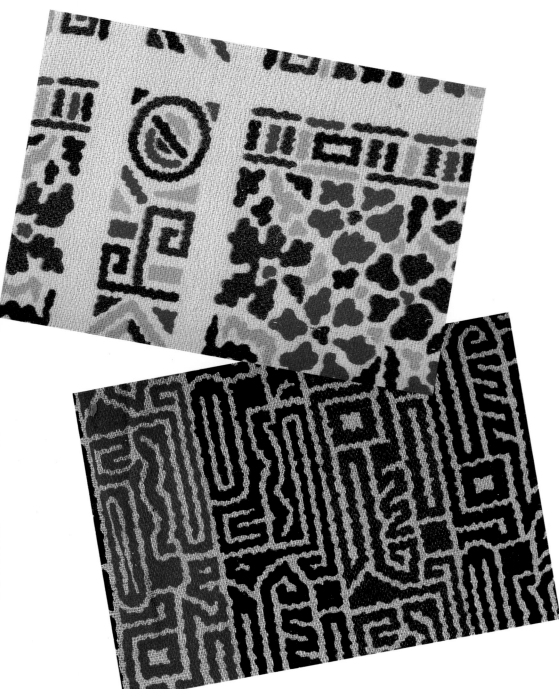

19

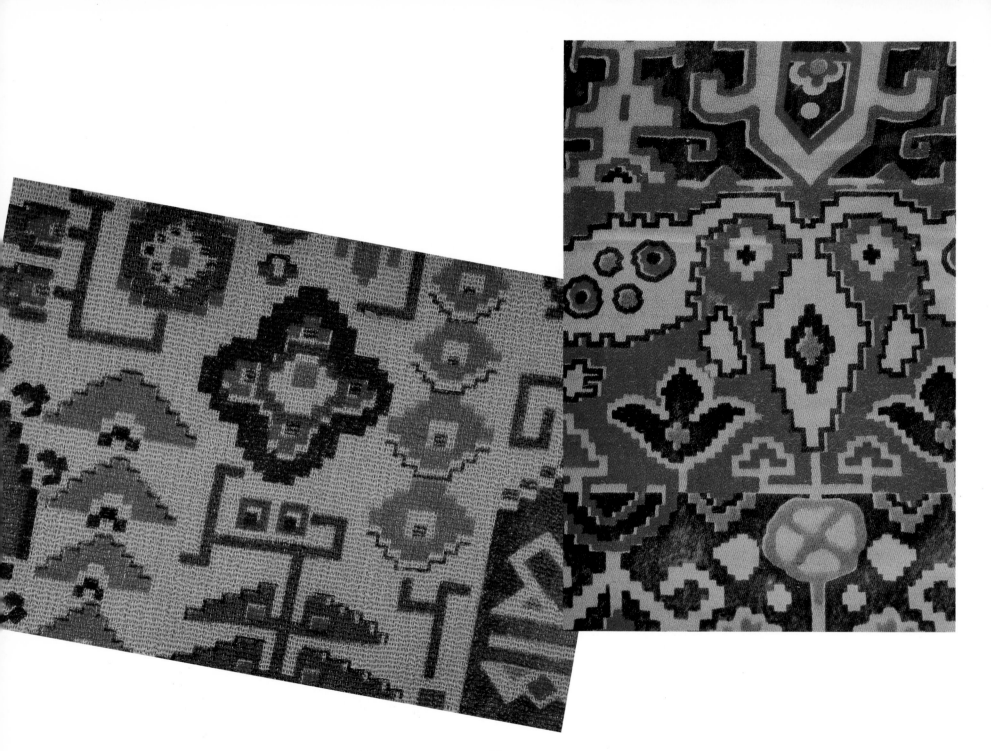

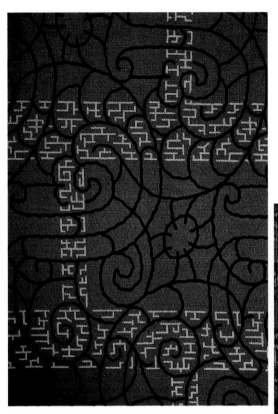

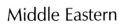

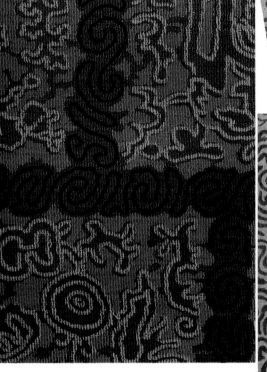

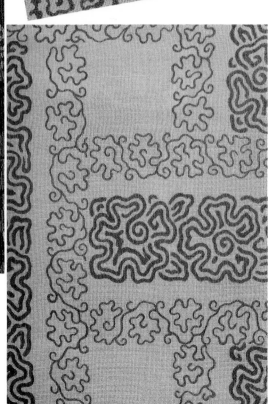

21

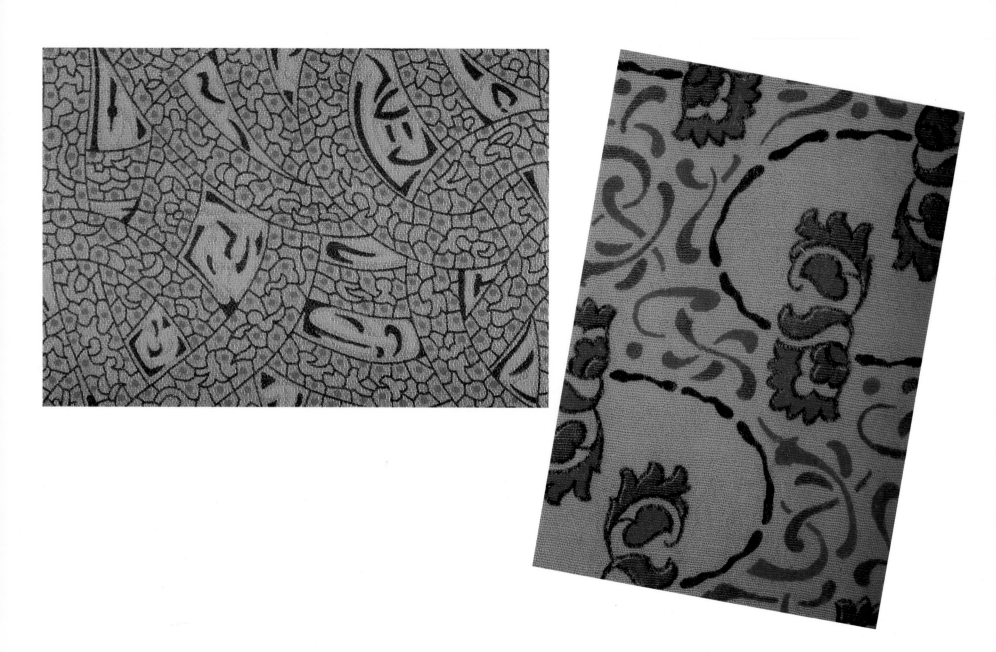

22

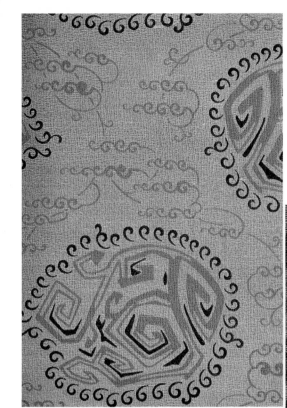

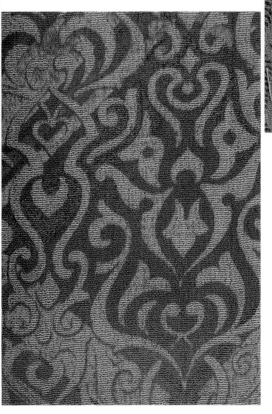

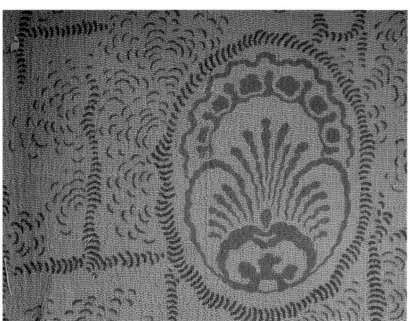

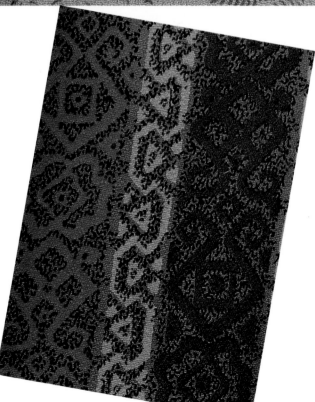

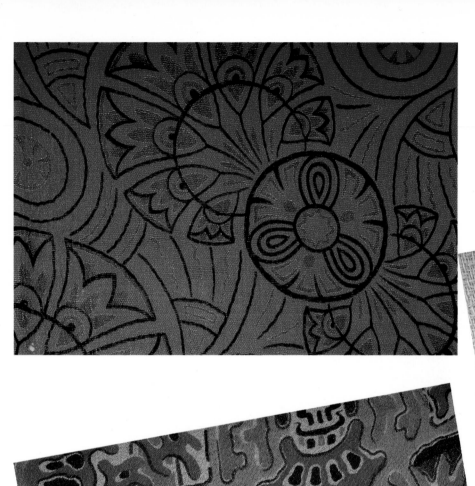

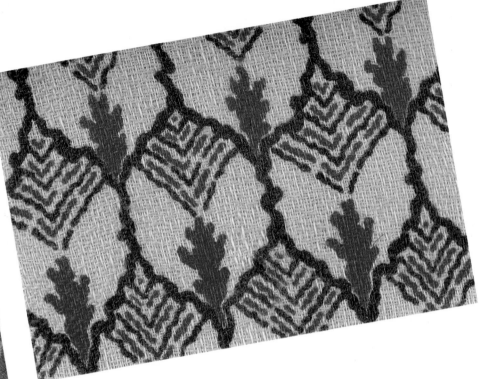

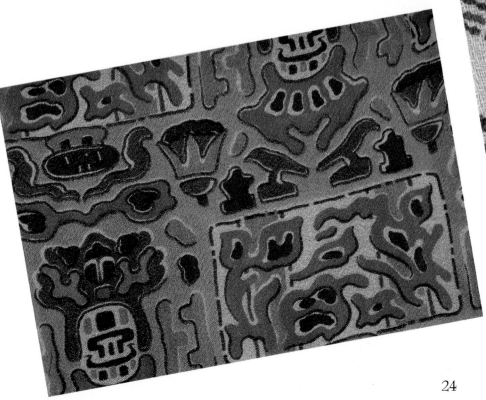

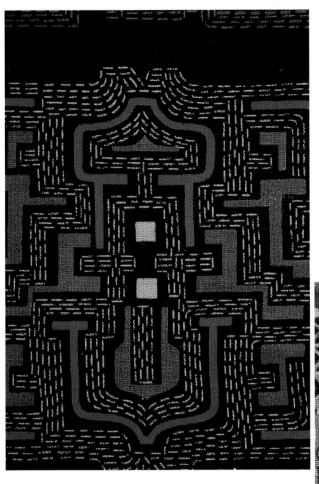
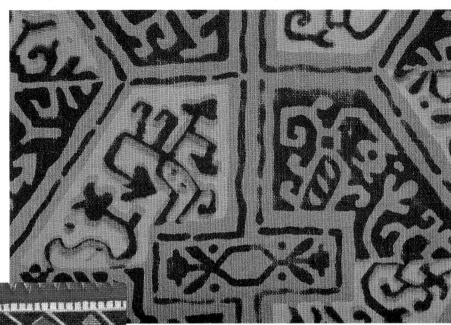
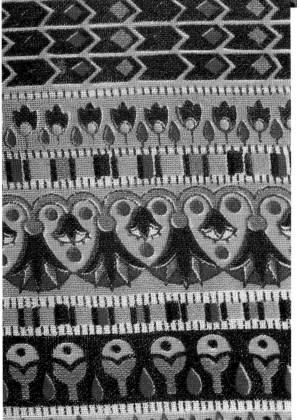

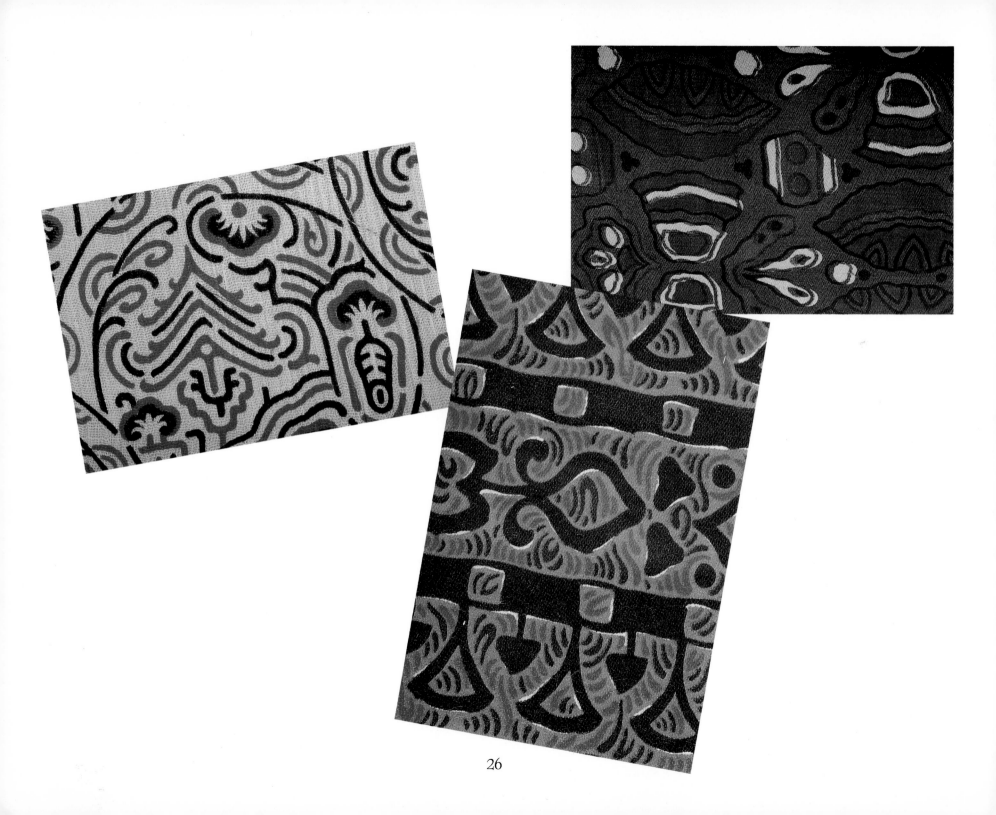

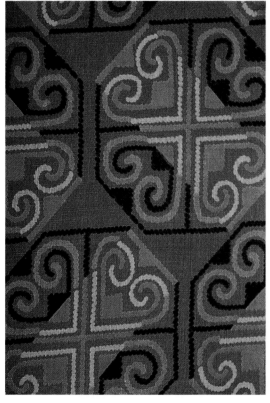

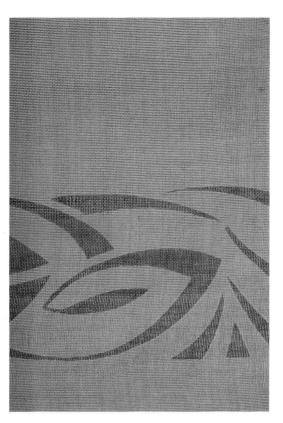

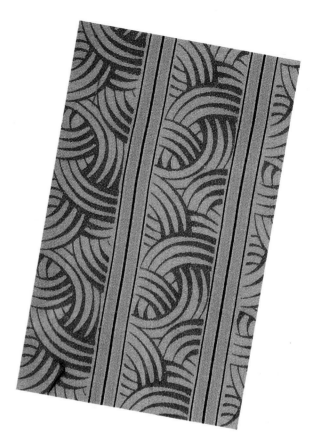

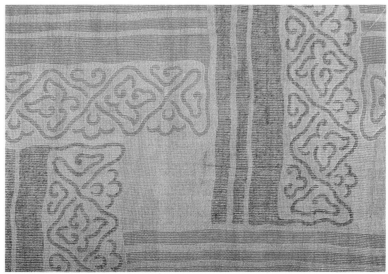

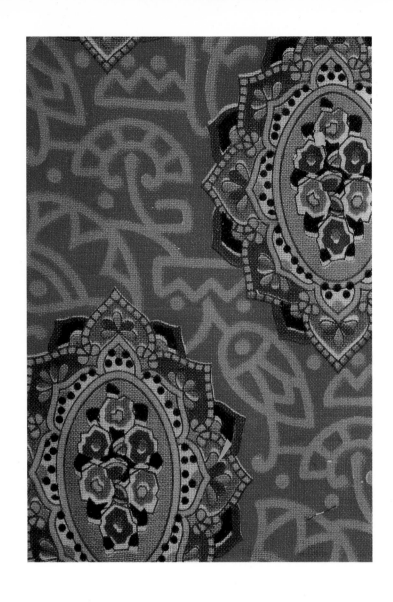

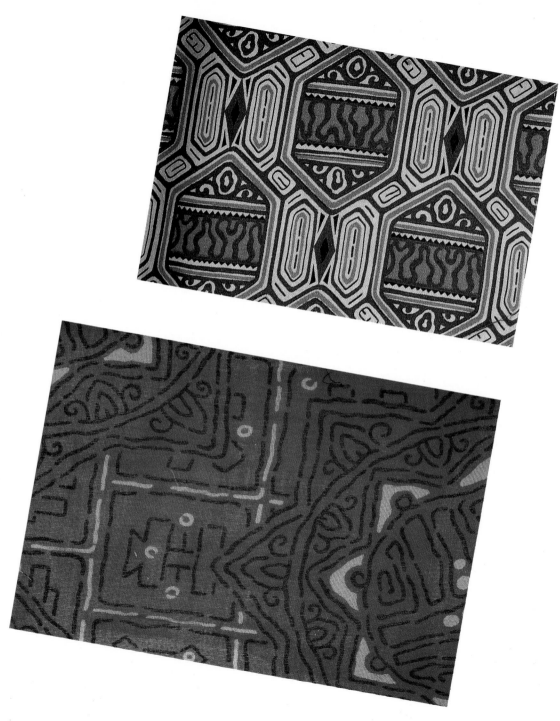

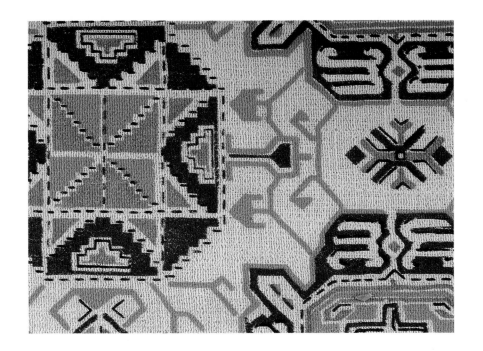

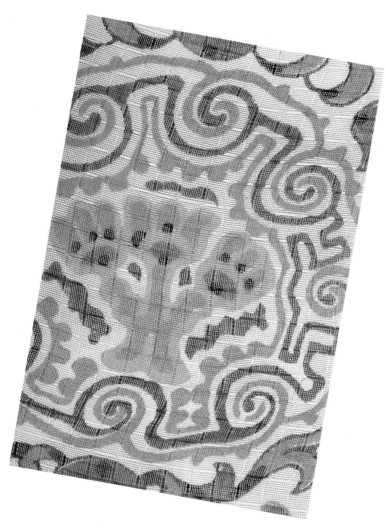

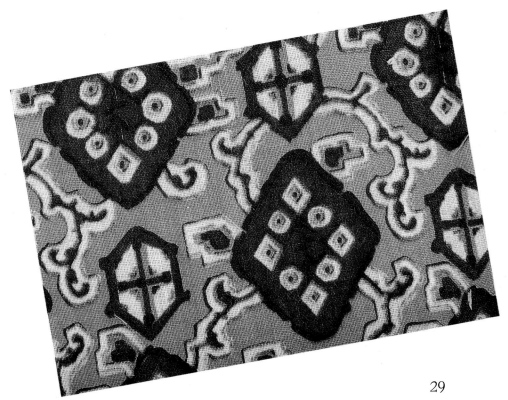

29

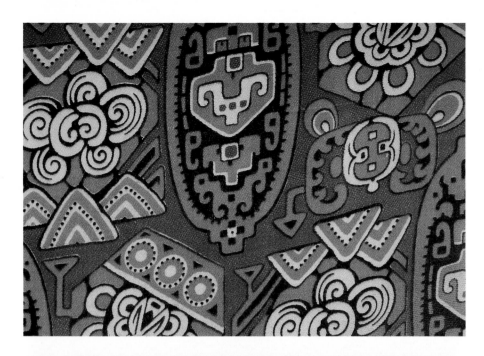

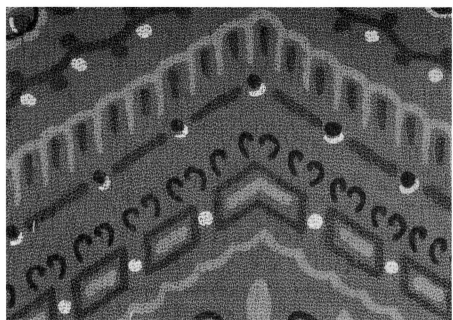

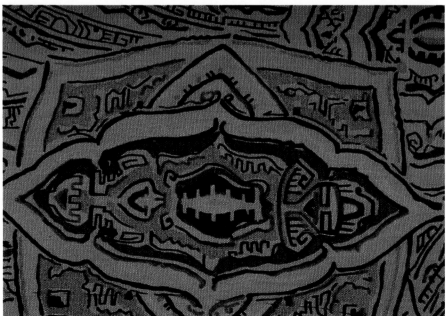

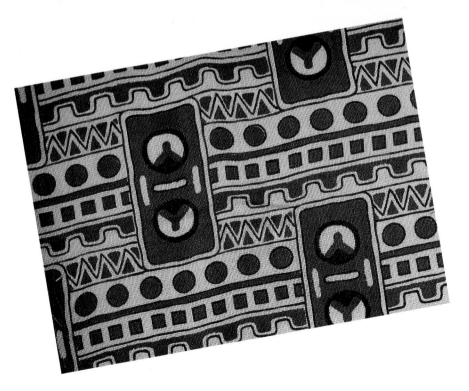

Indian

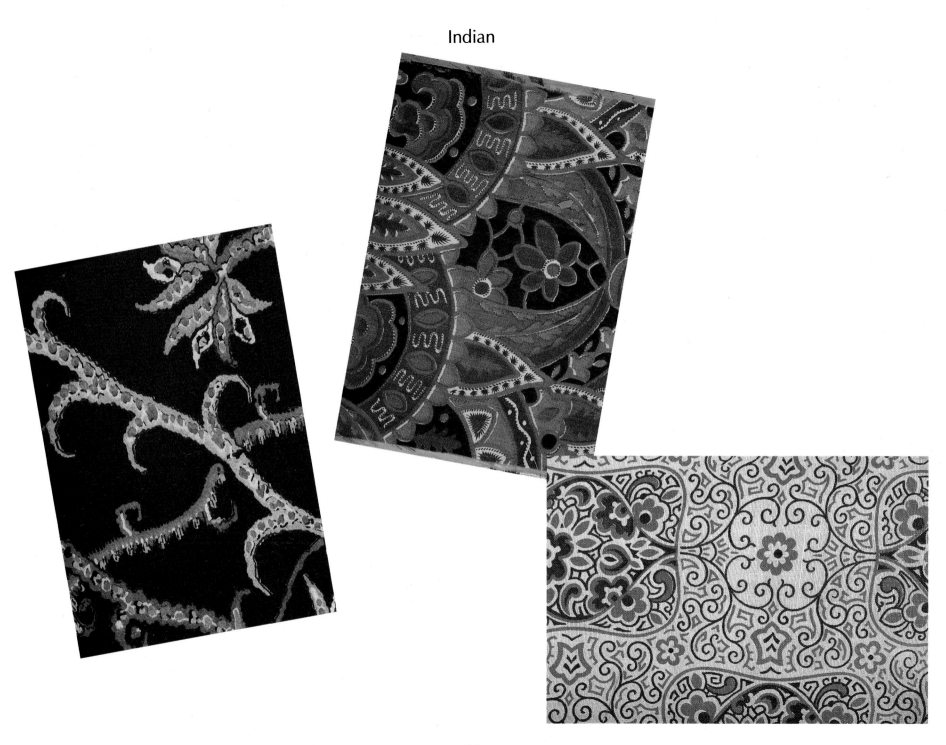

31

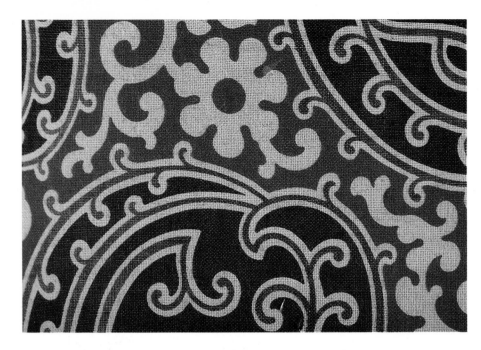

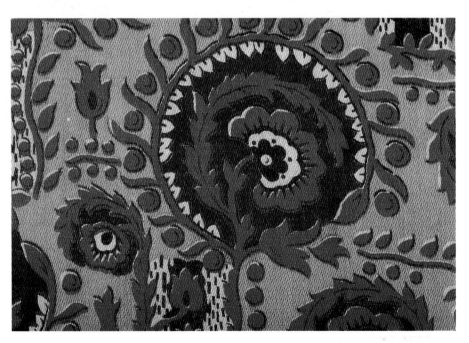

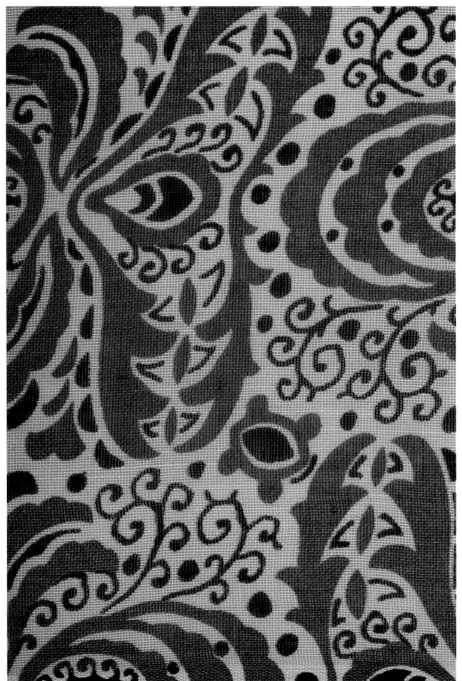

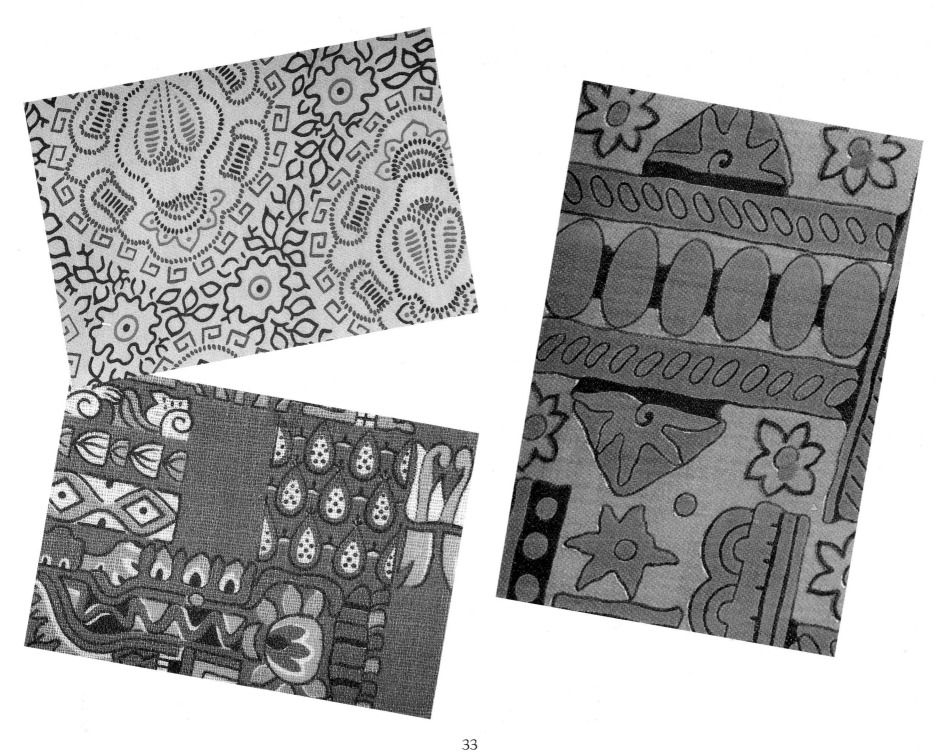

33

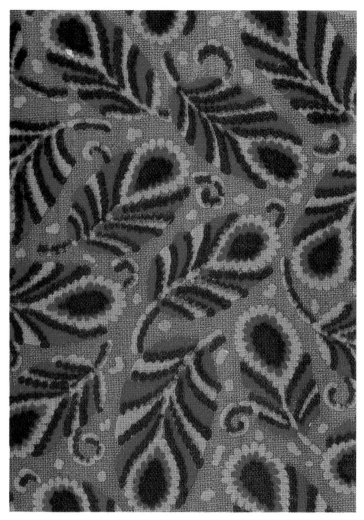

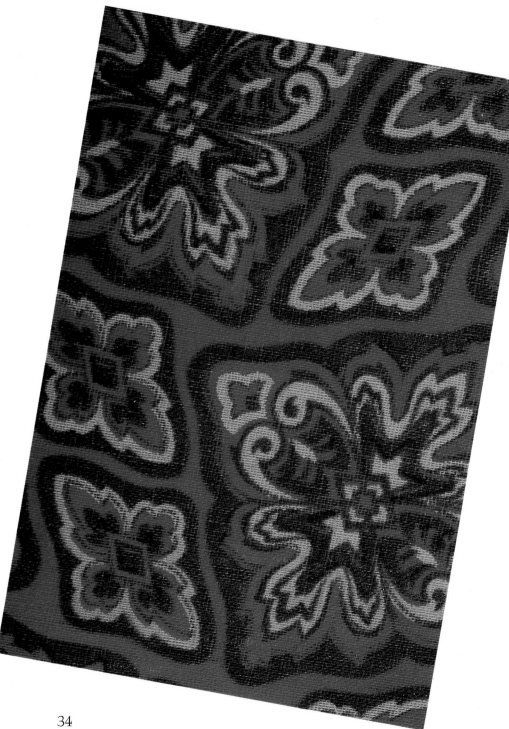

34

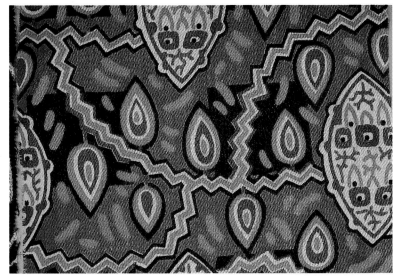

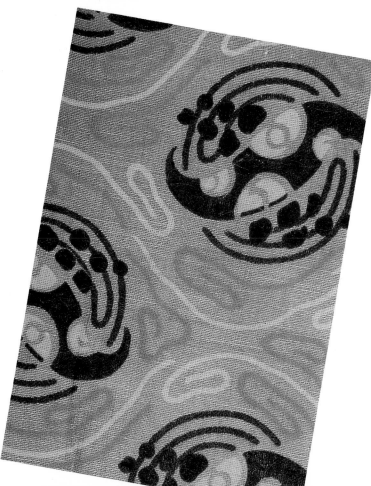

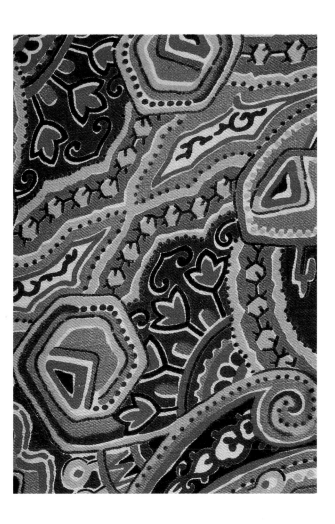

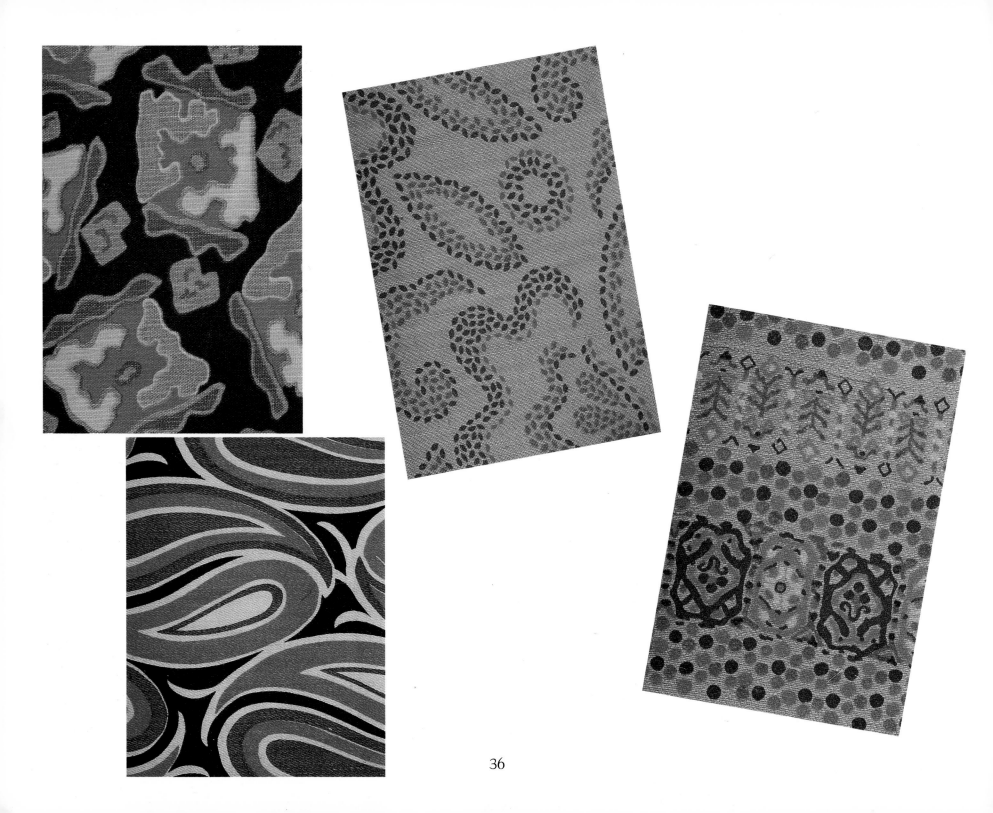

Floral

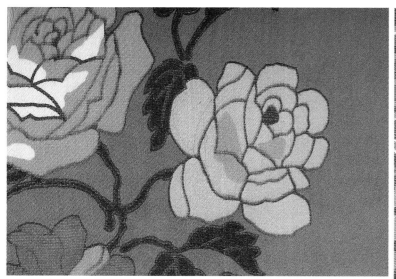

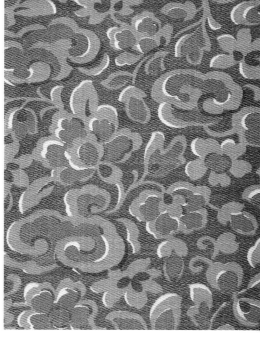

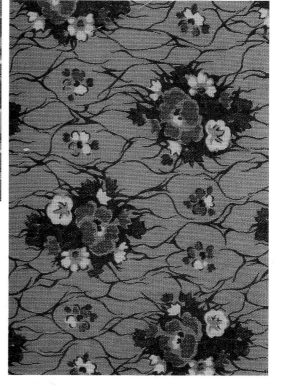

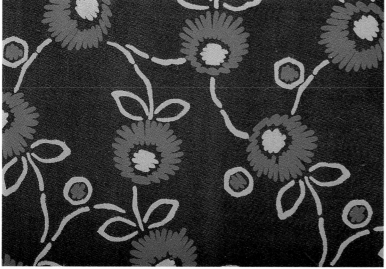

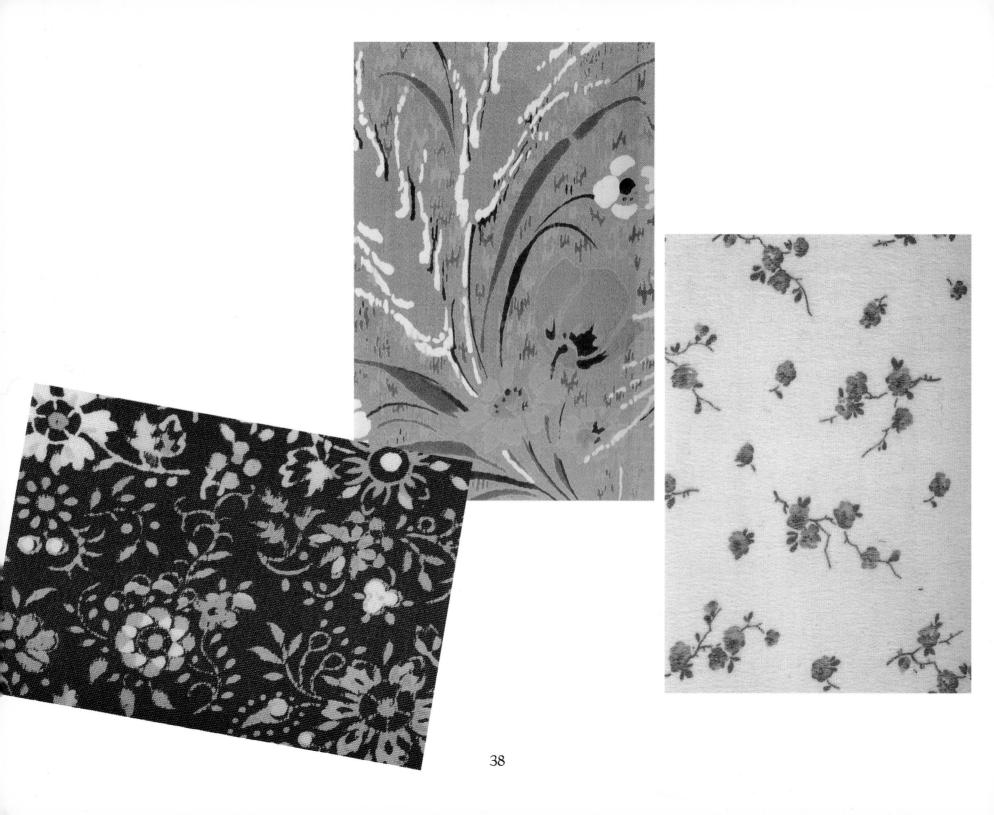

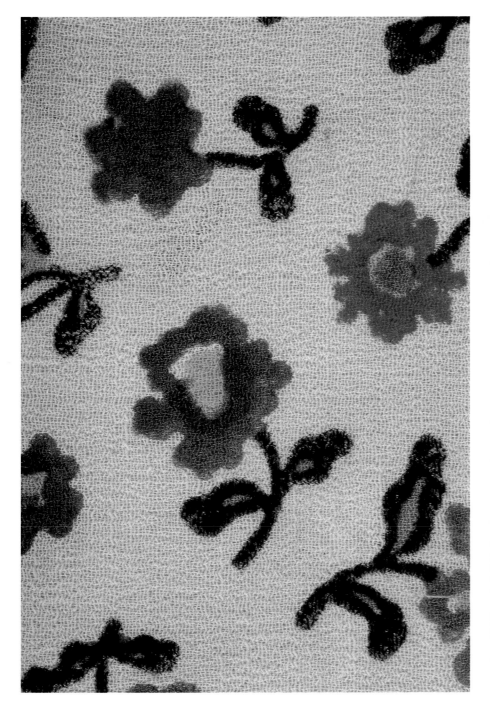
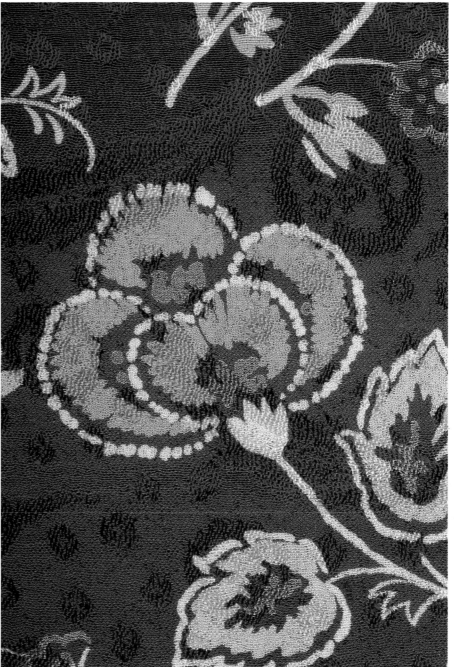

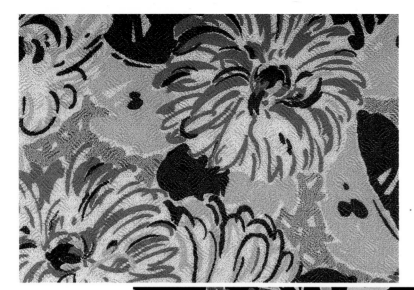

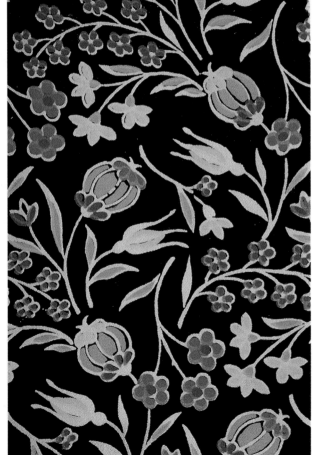

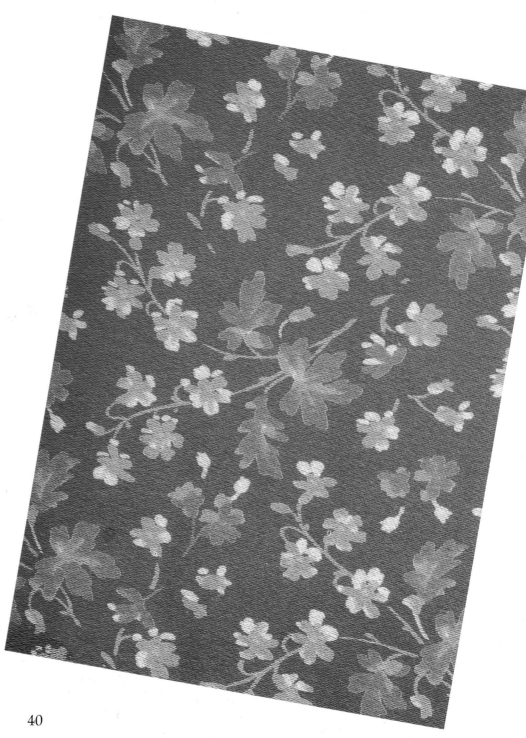

40

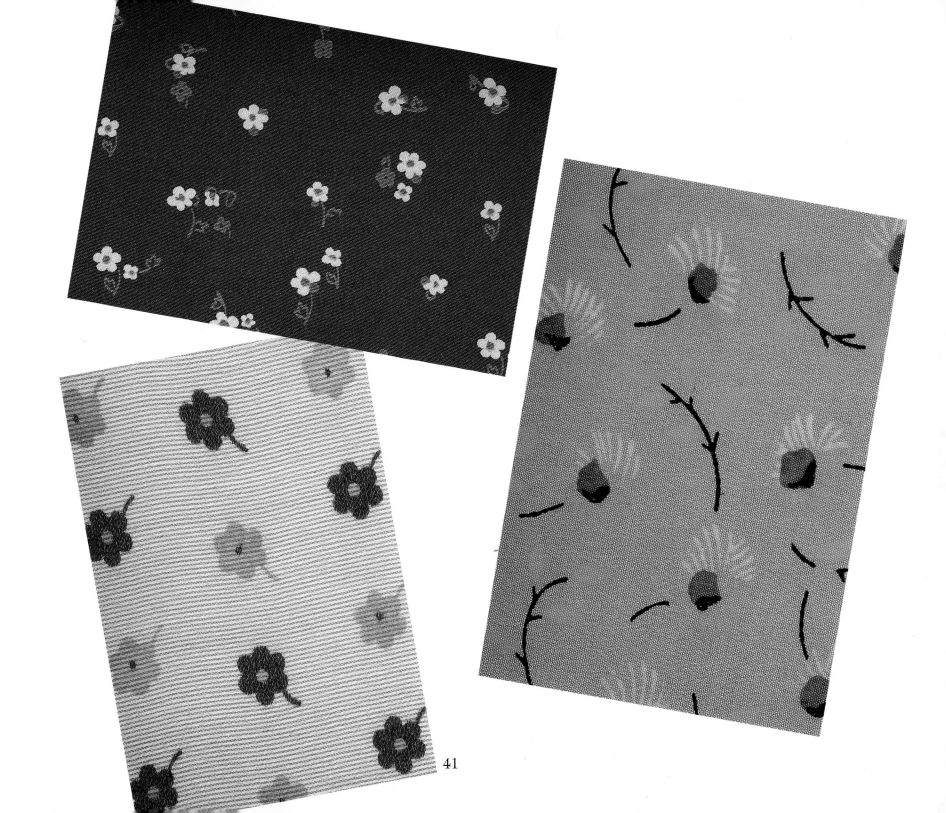

41

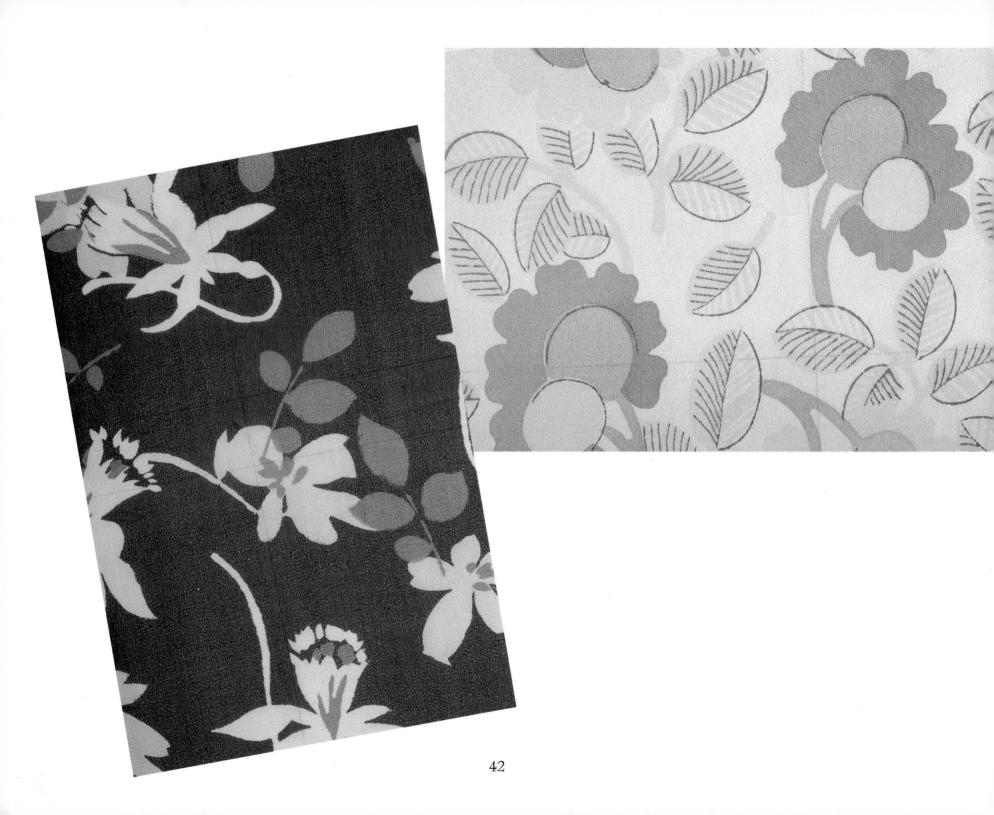

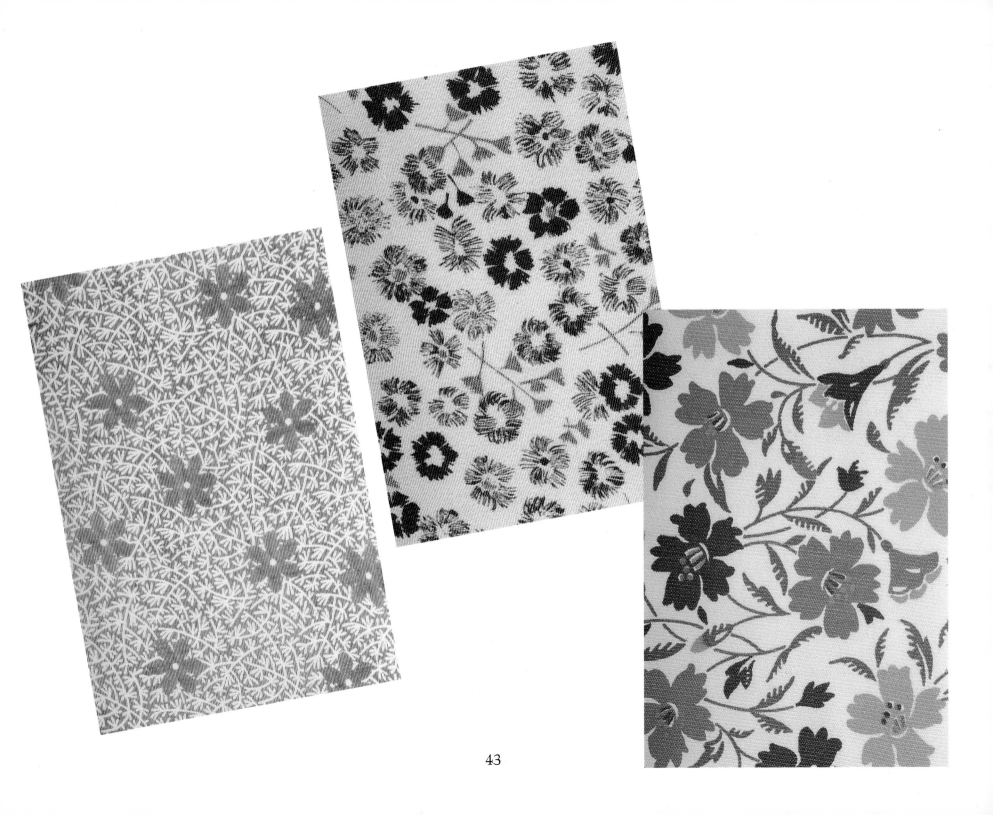

43

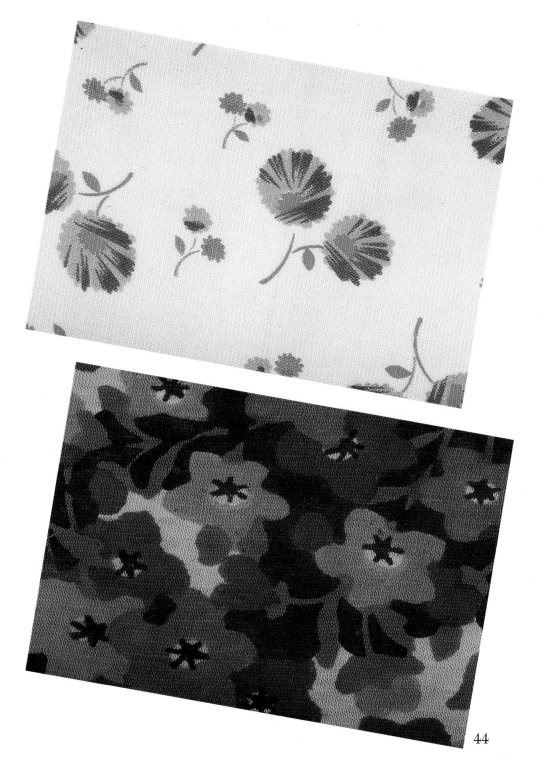

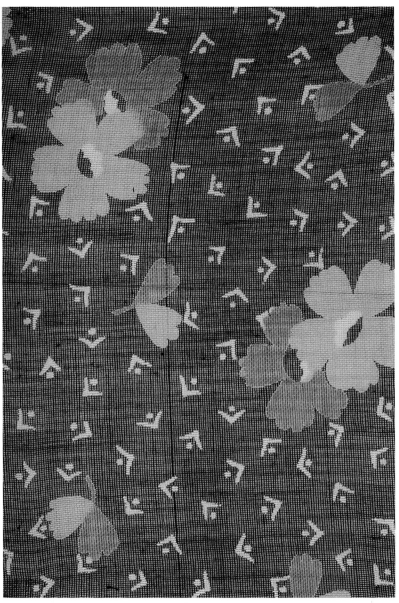

44

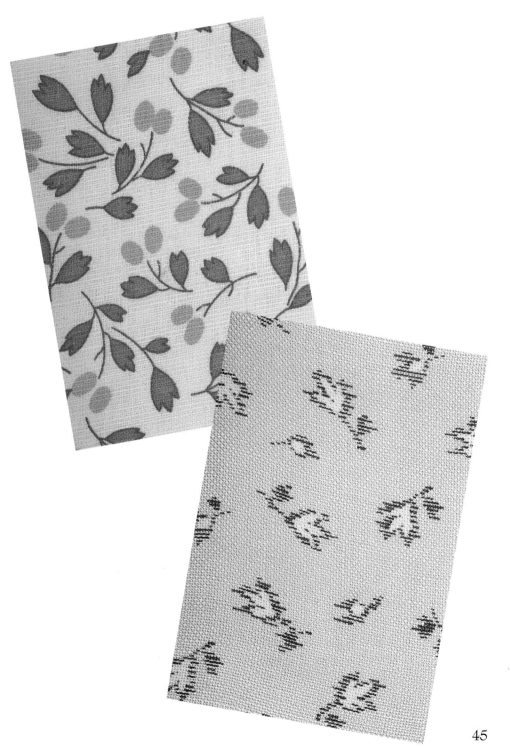

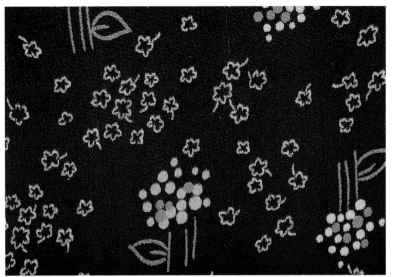

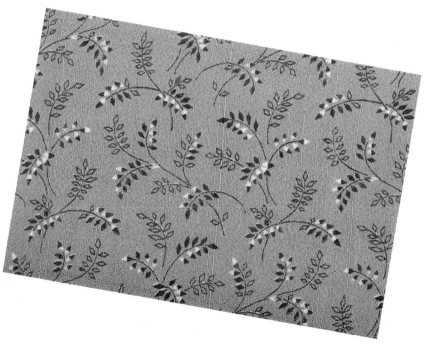

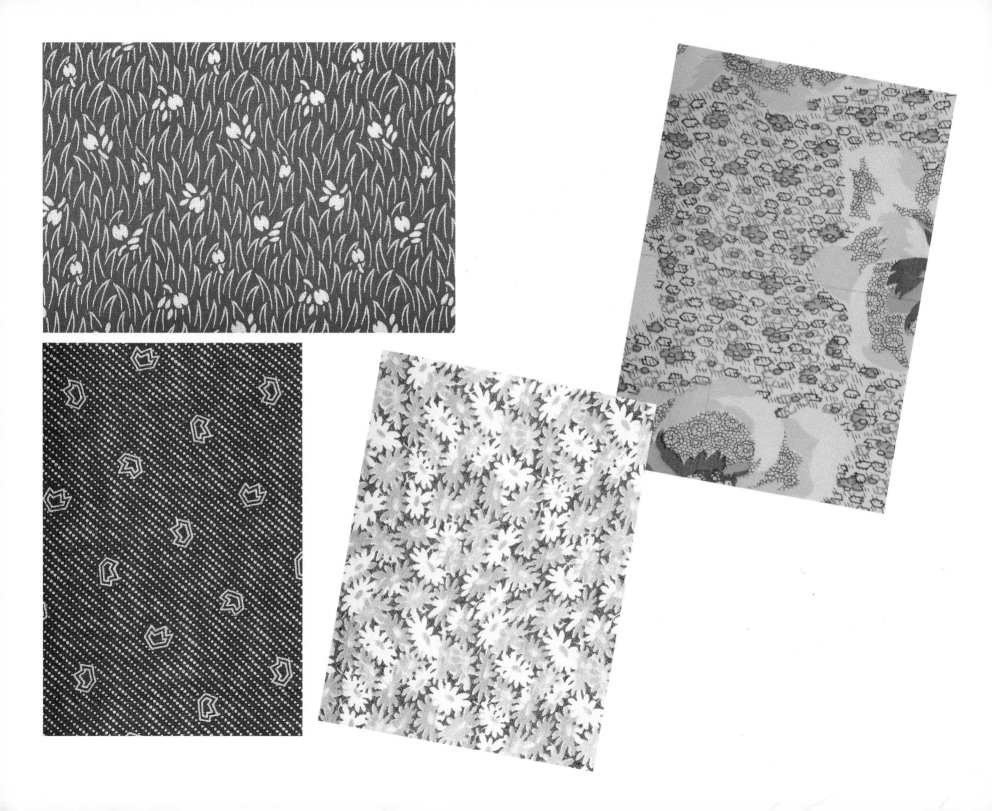

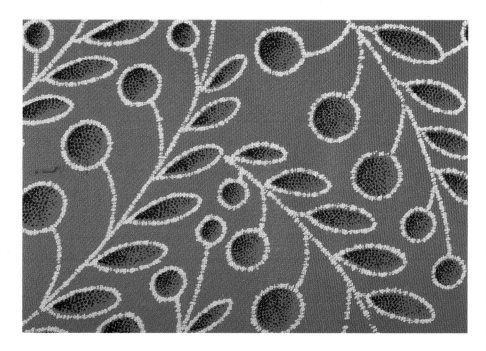

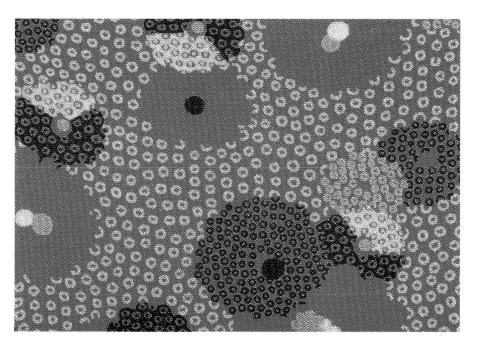

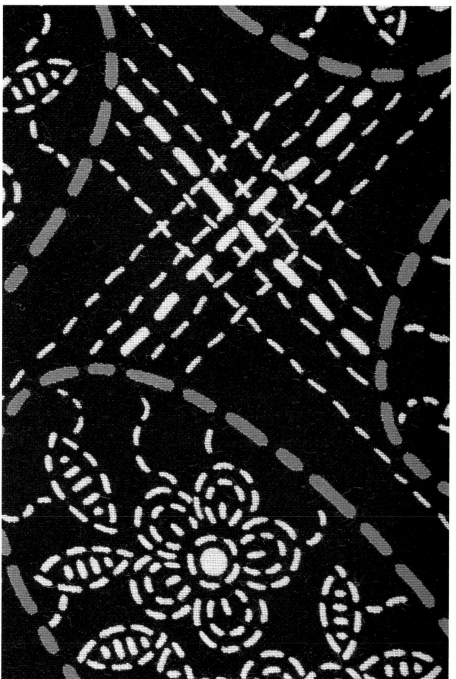

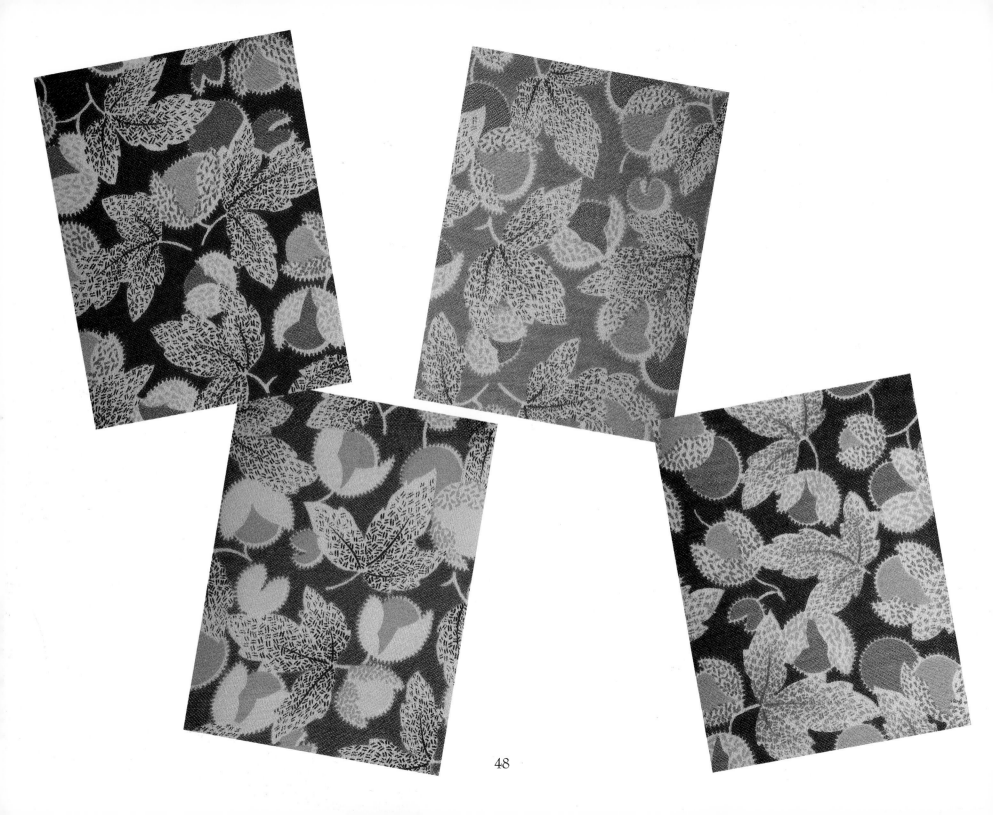

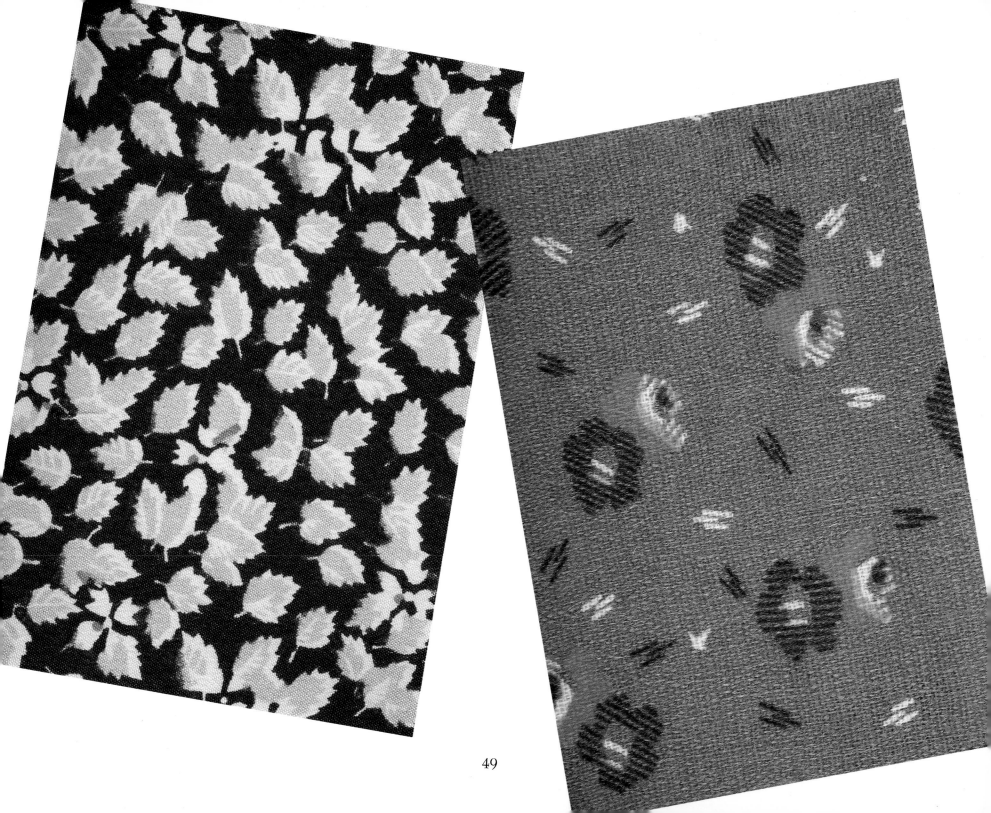

49

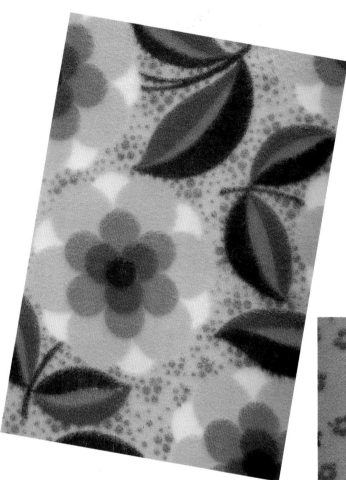
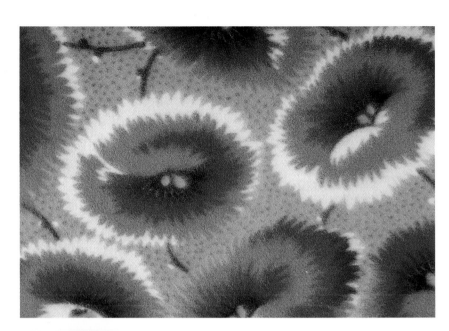
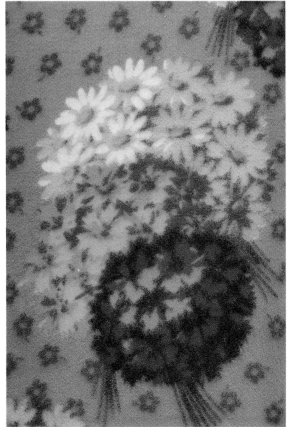

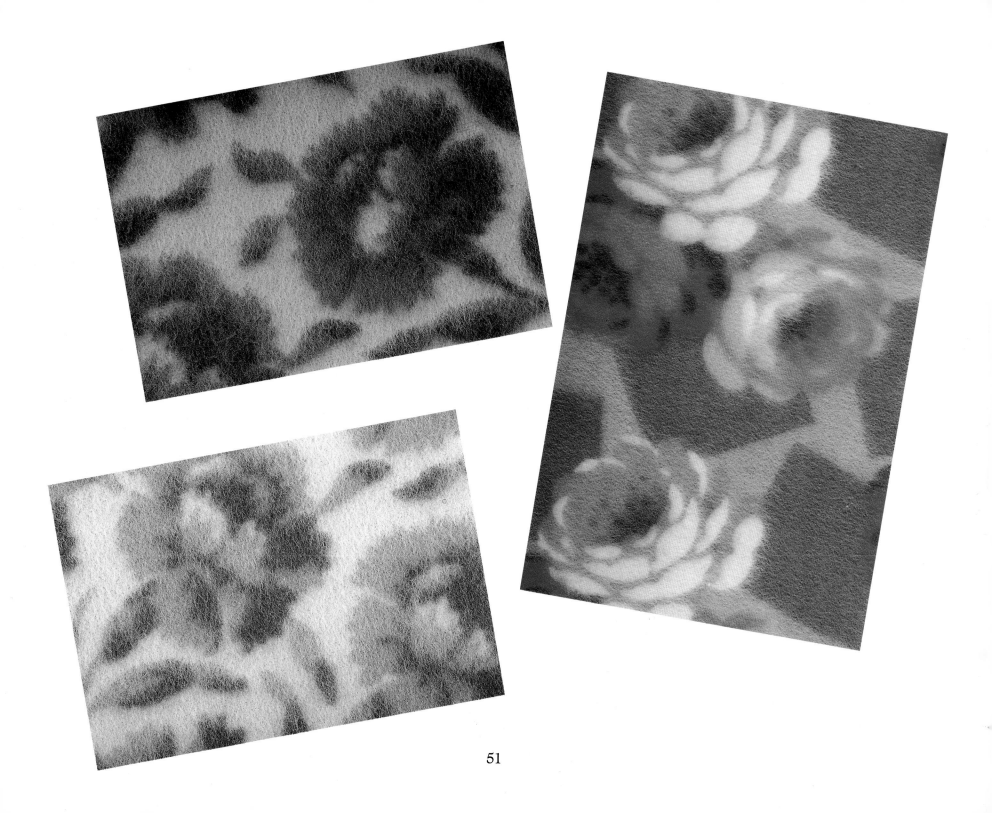

51

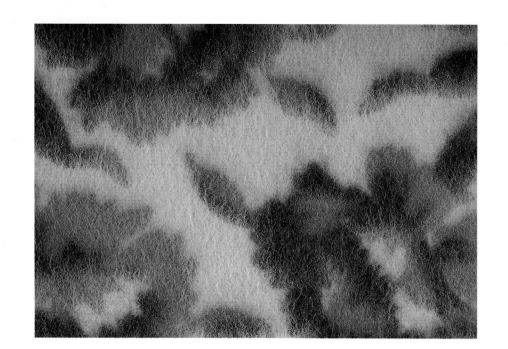

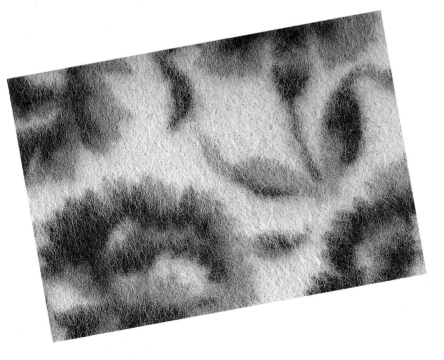

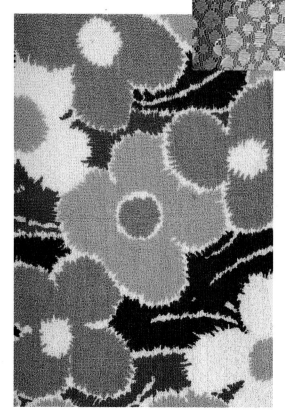

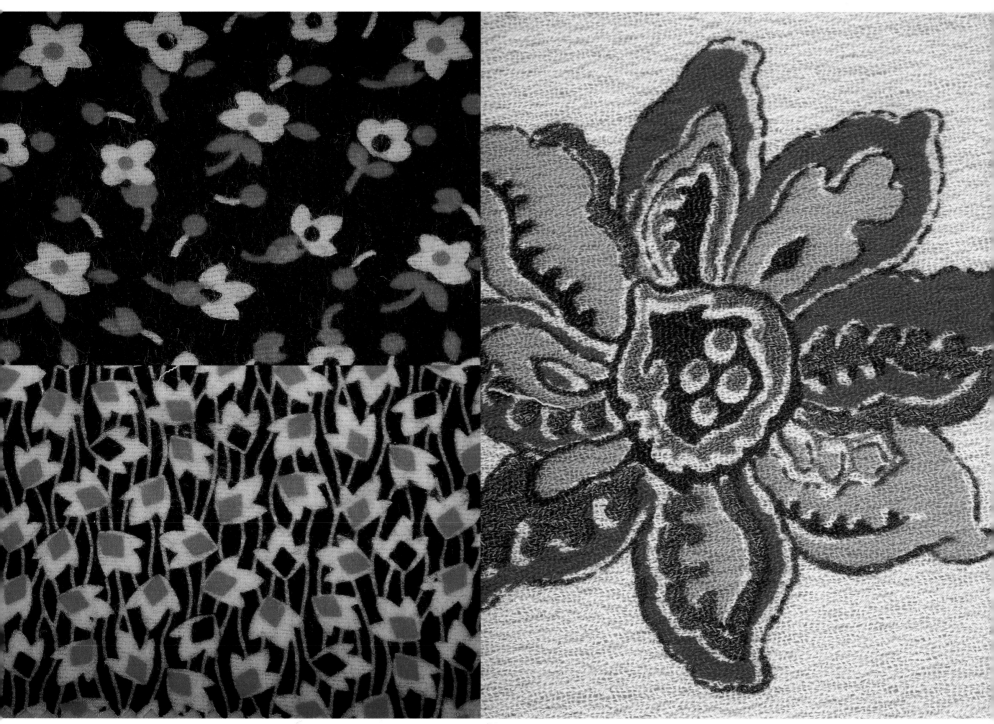

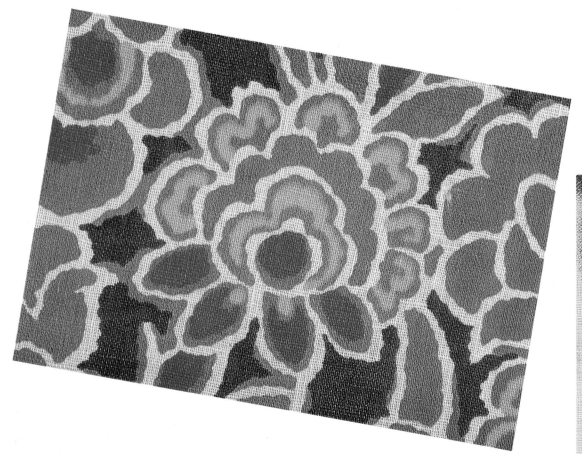

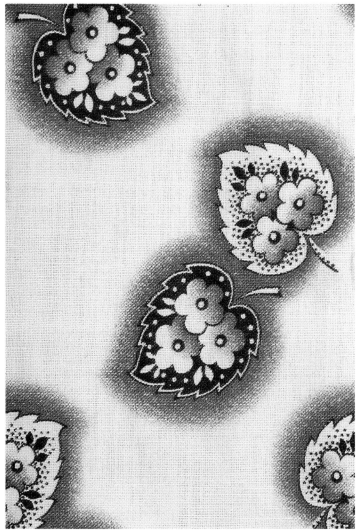

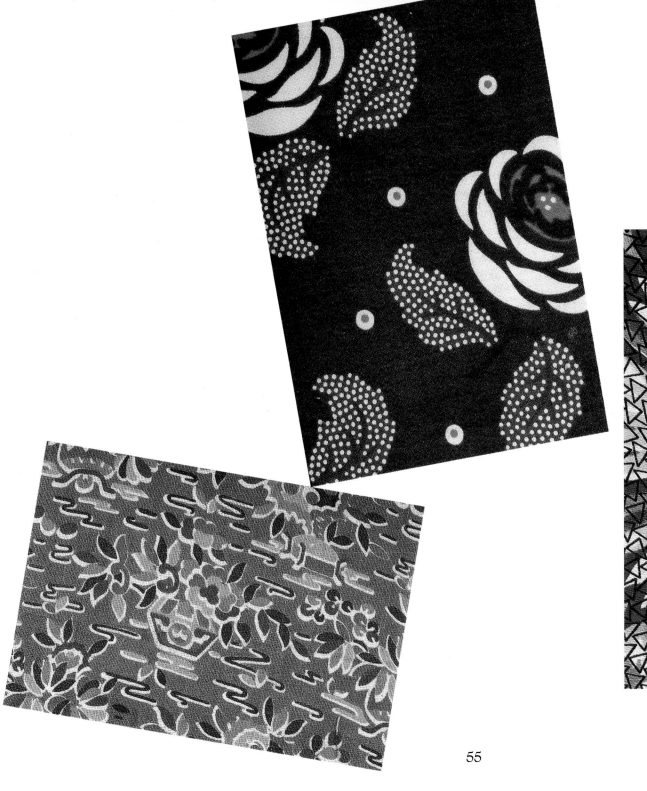
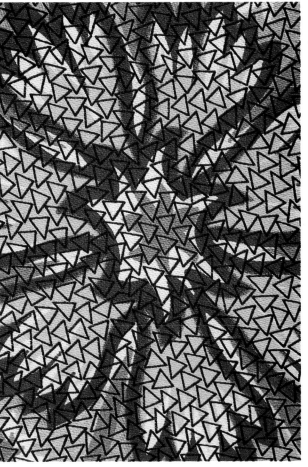

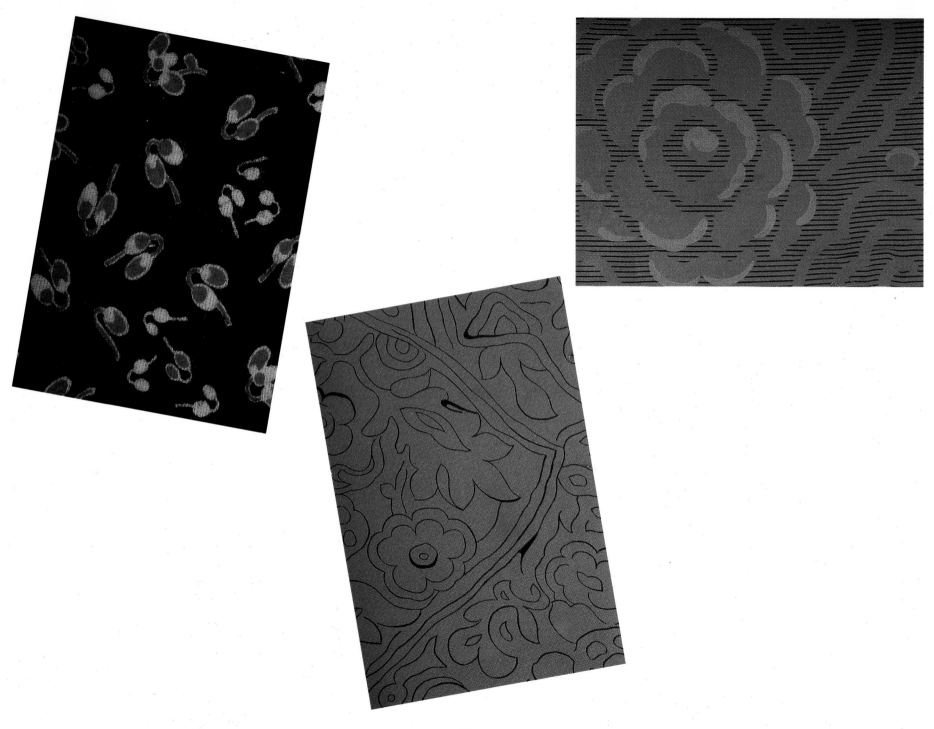

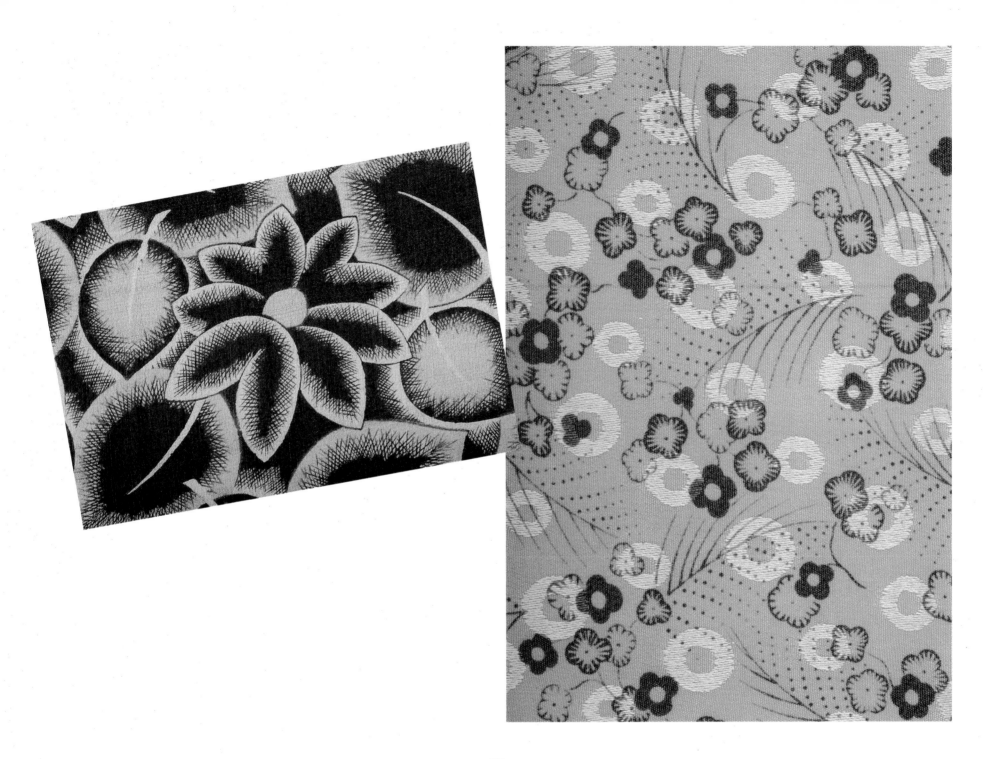

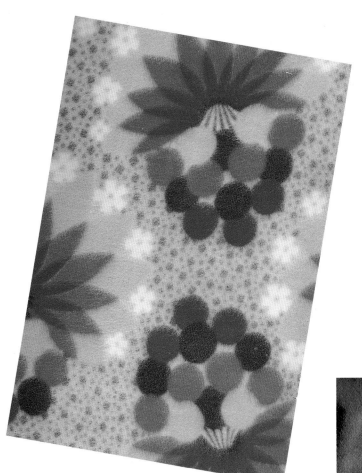

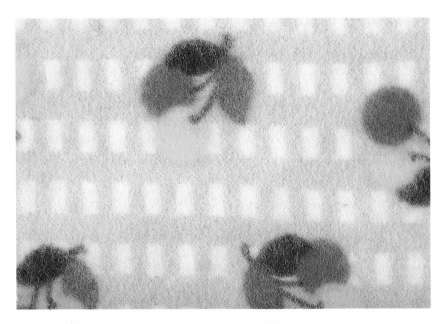

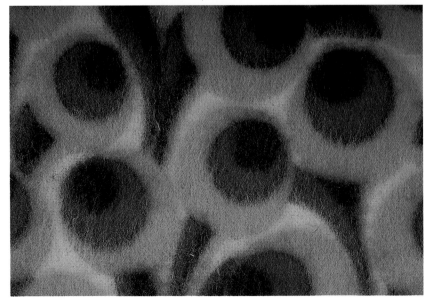

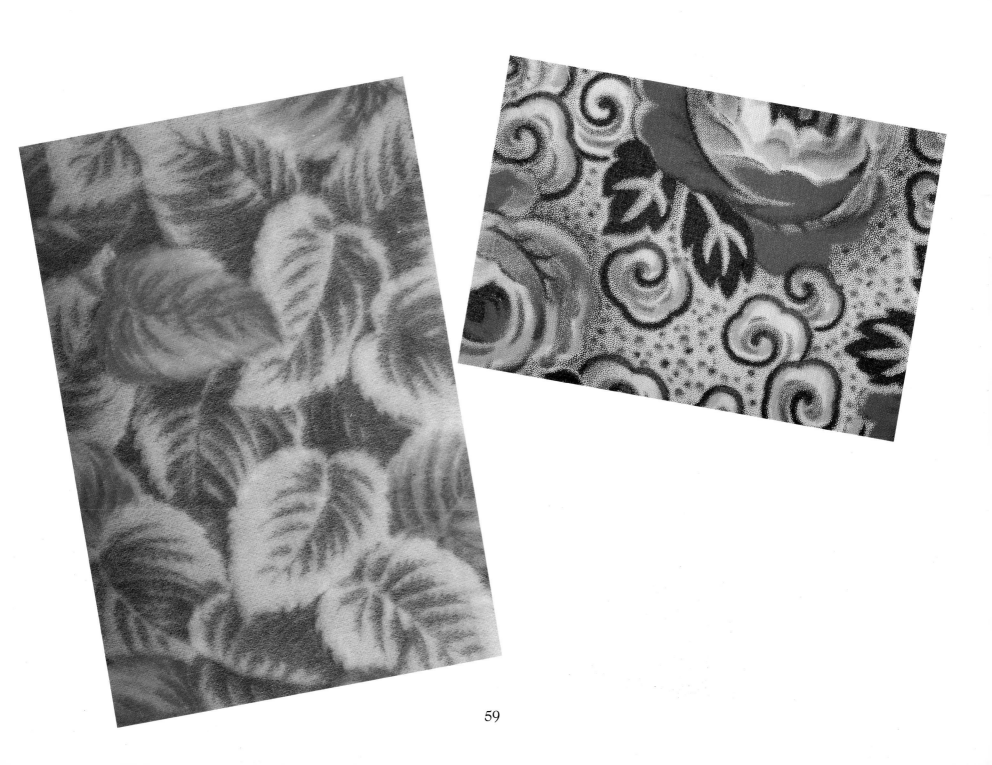

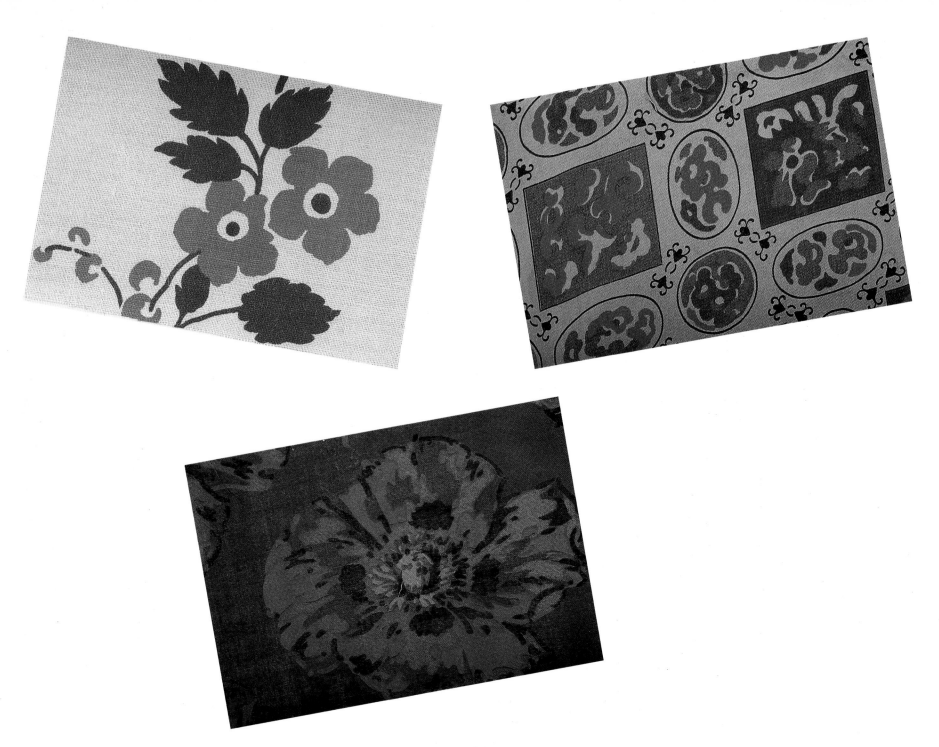

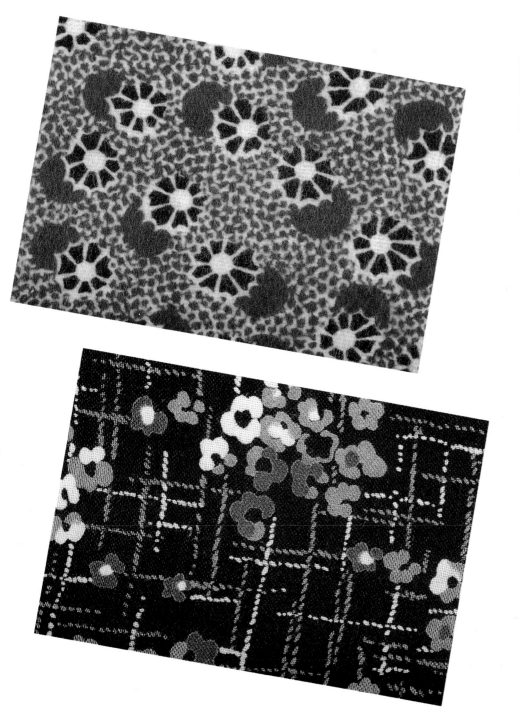

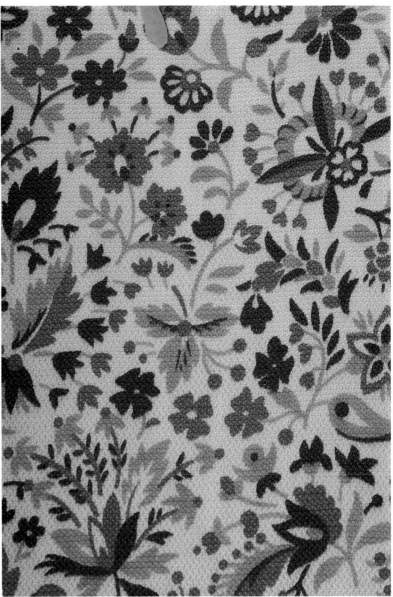

61

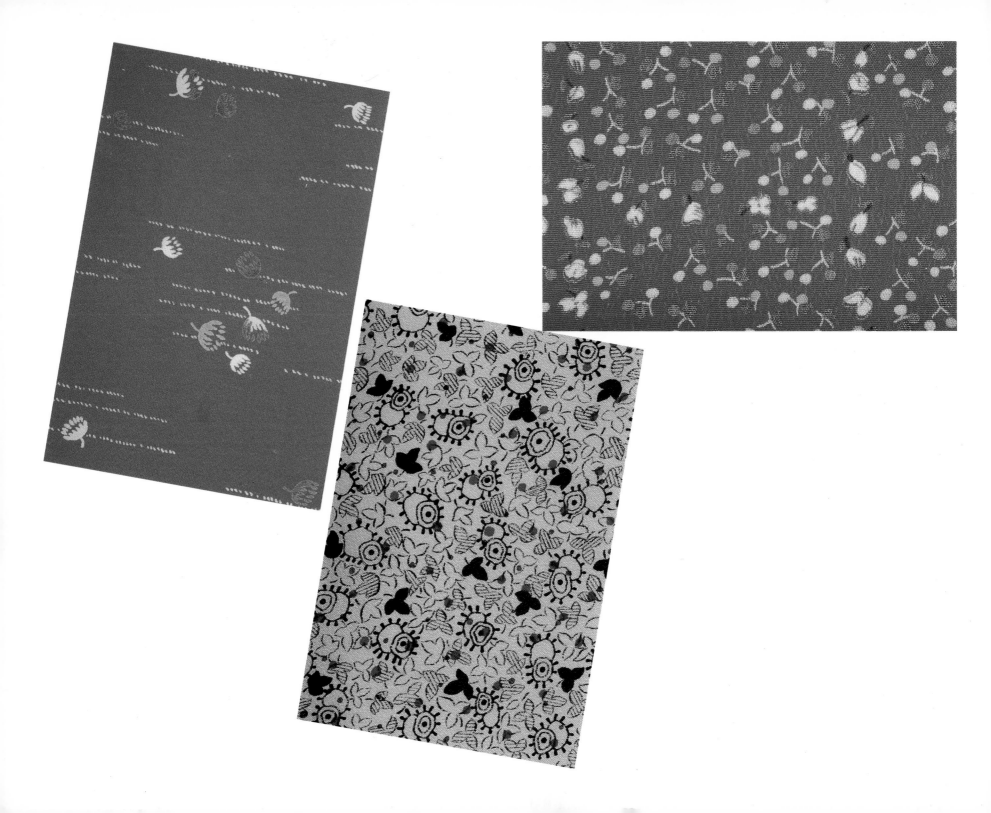

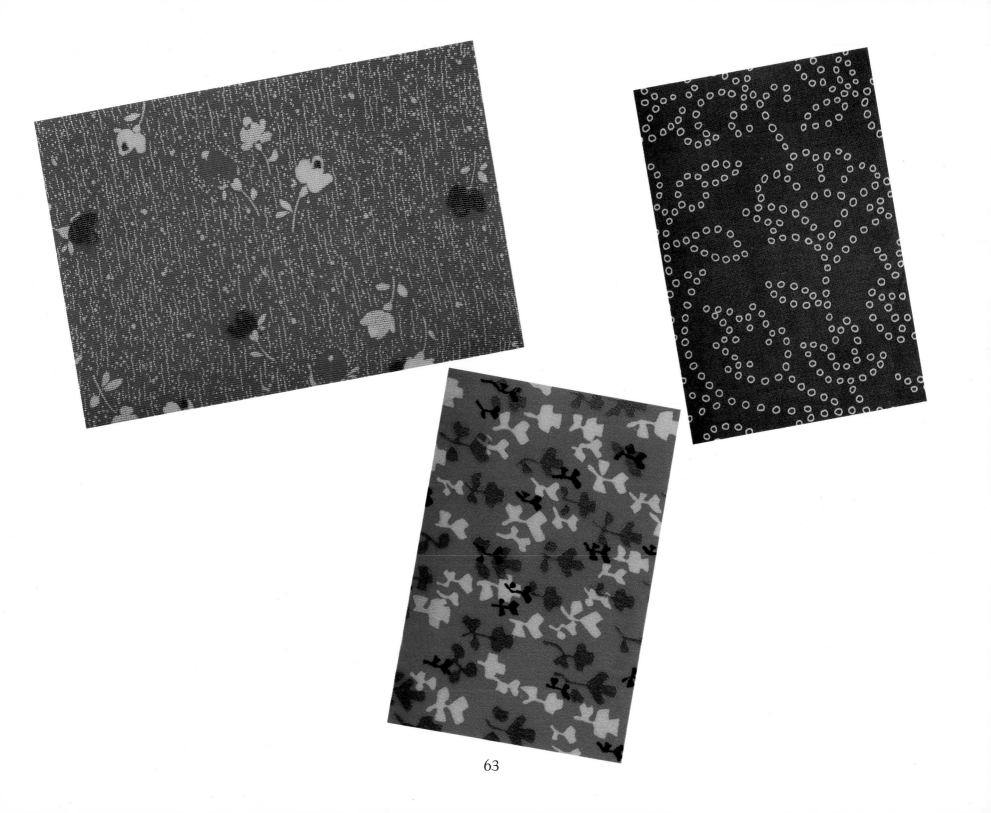

63

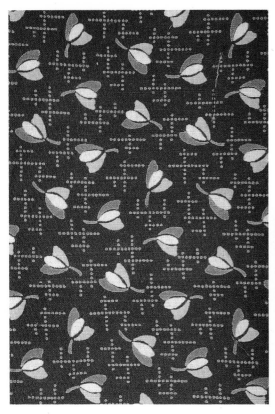

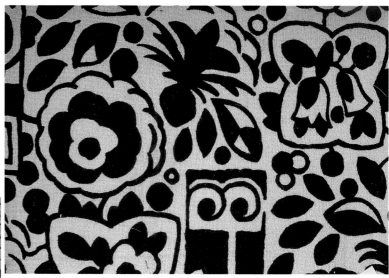

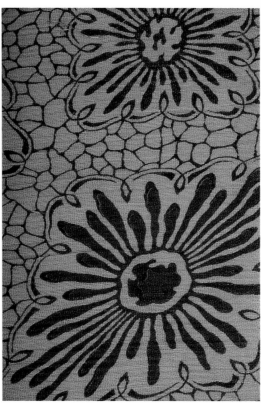

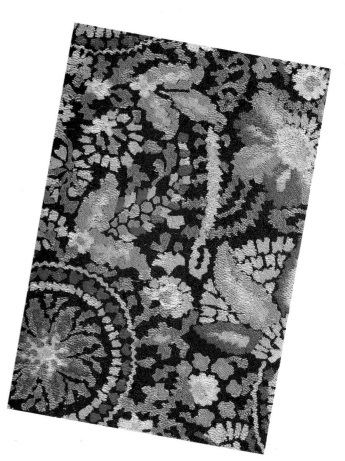

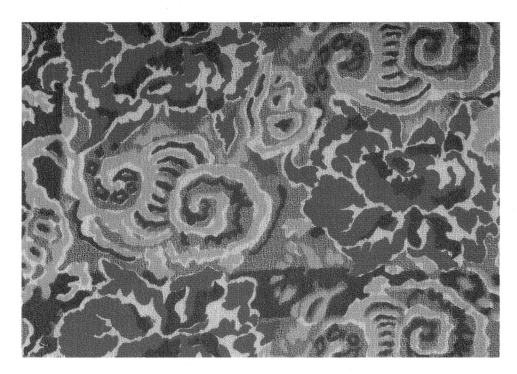

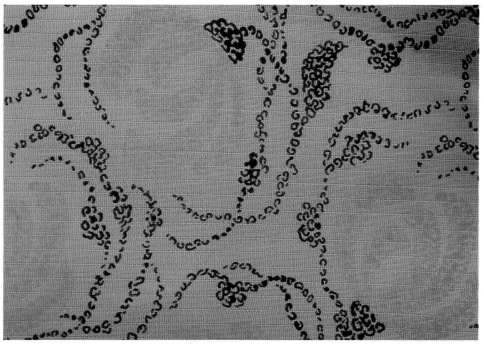

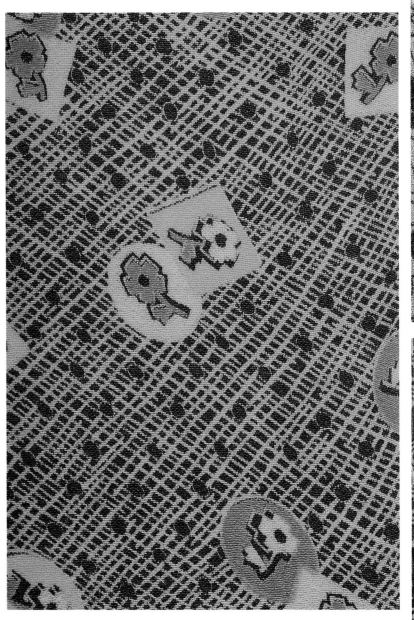

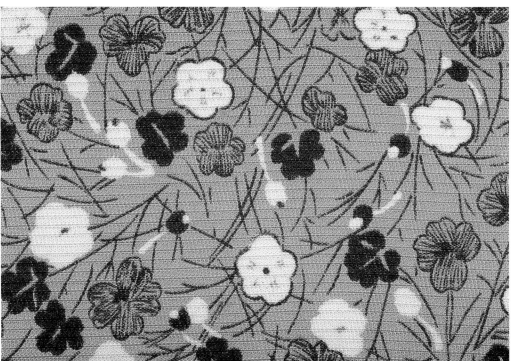

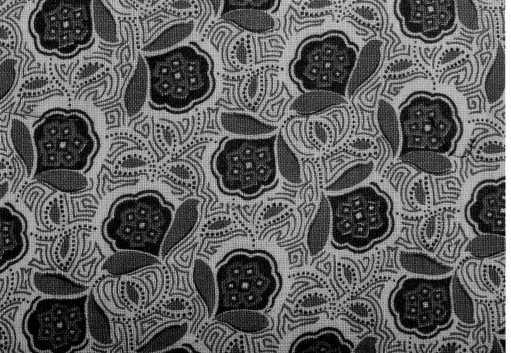

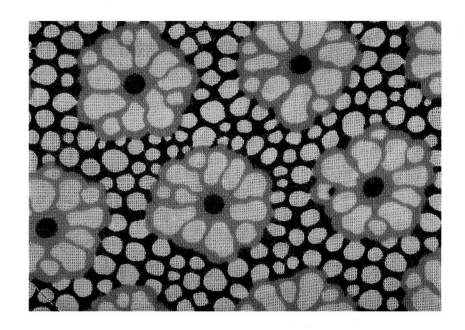

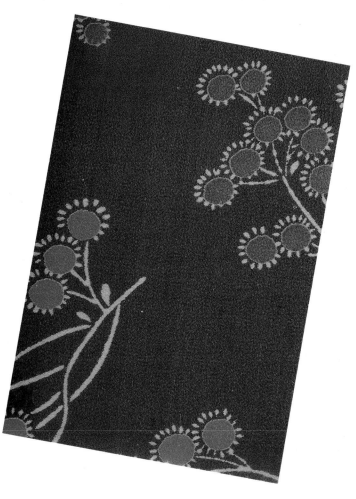

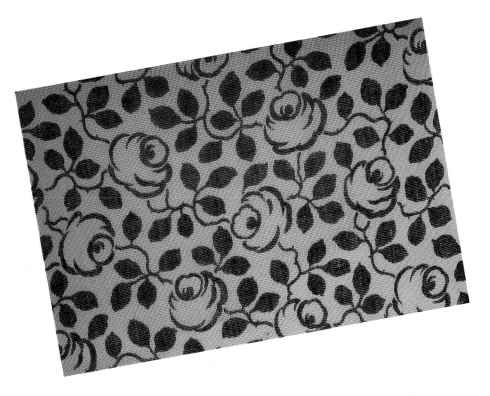

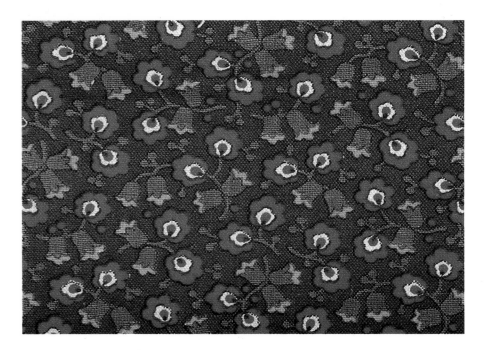

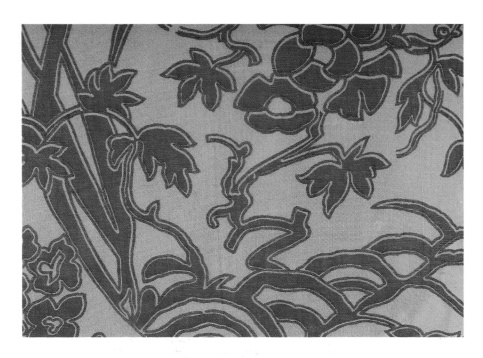

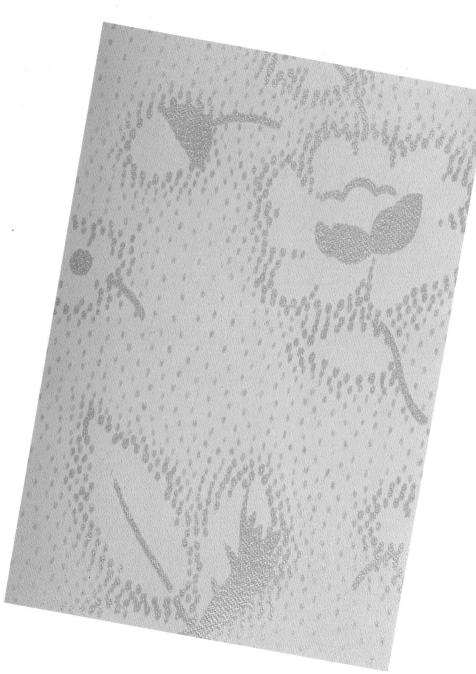

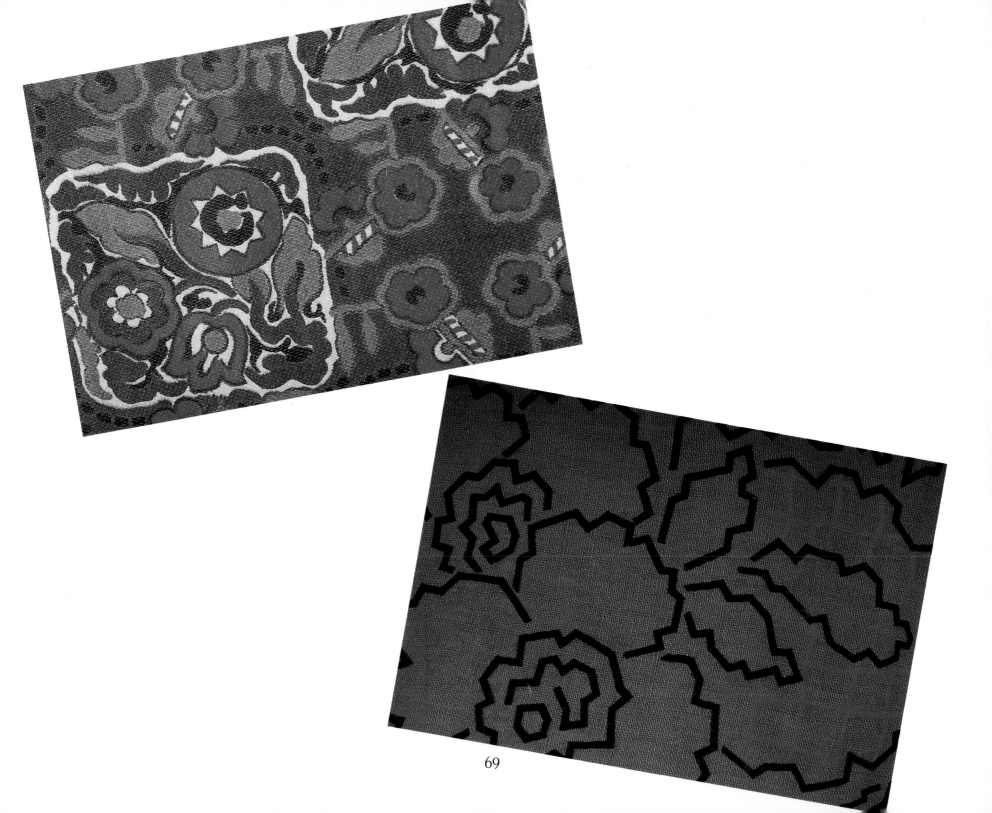

69

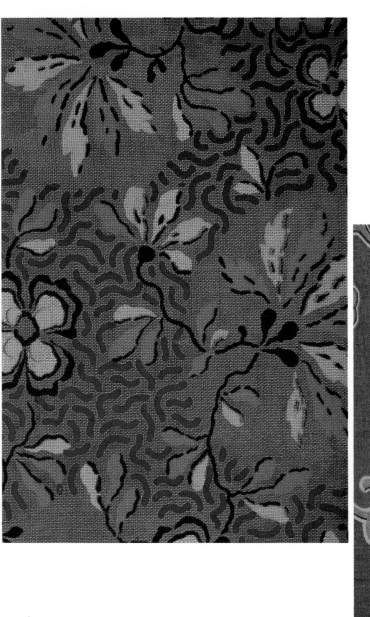
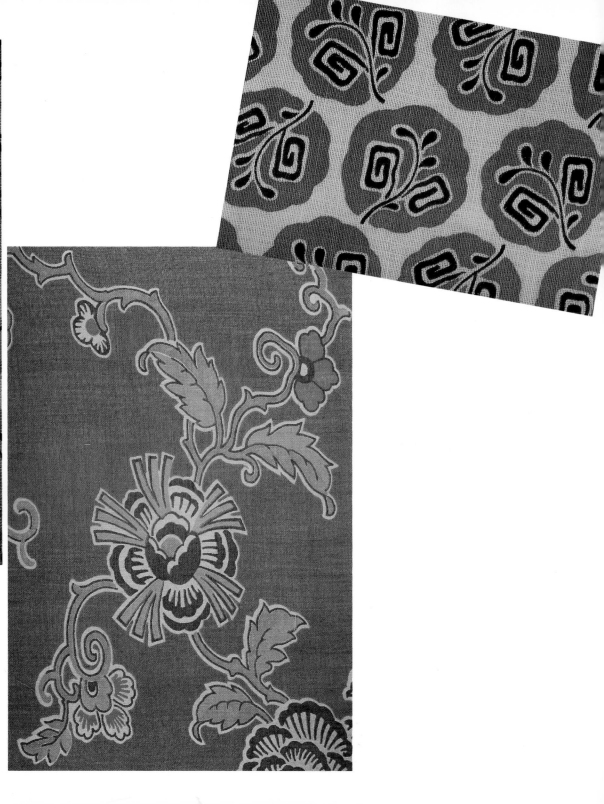

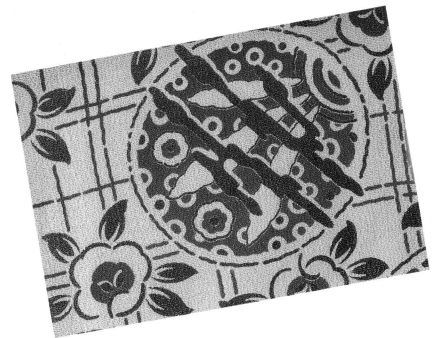

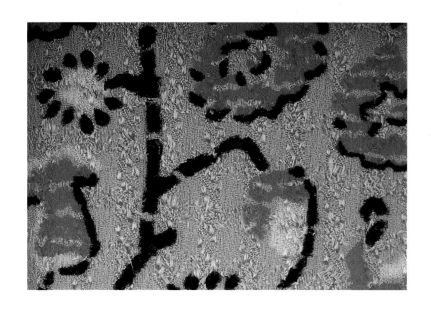

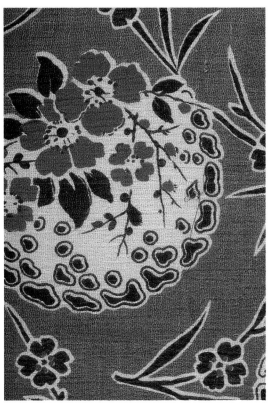

71

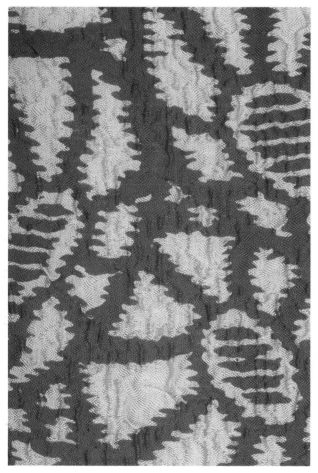 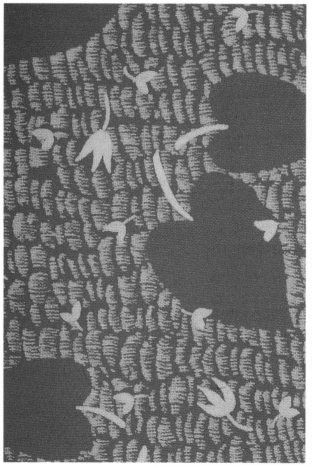 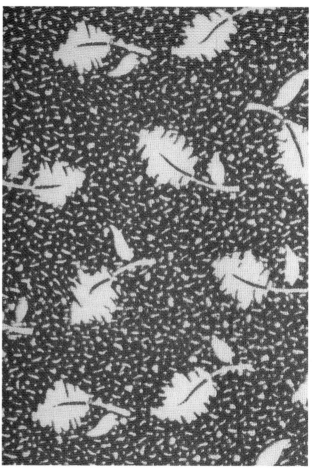

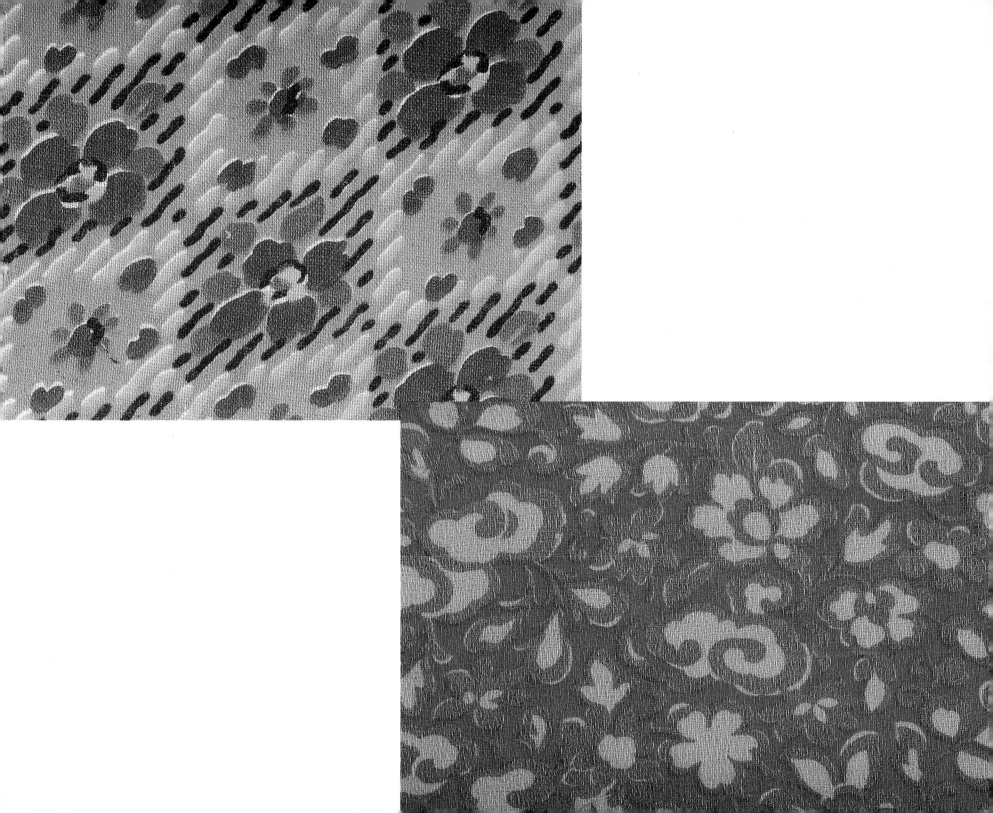

Geometric

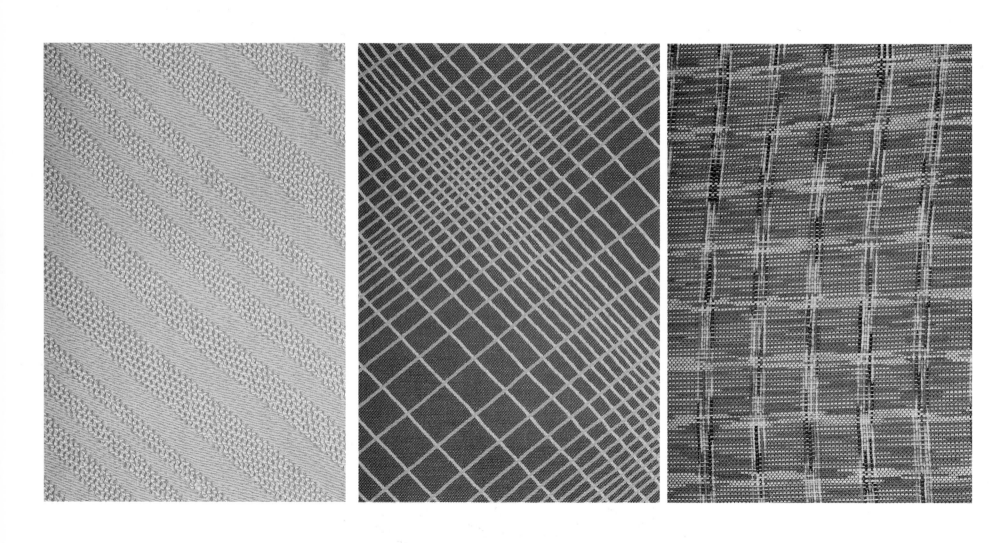

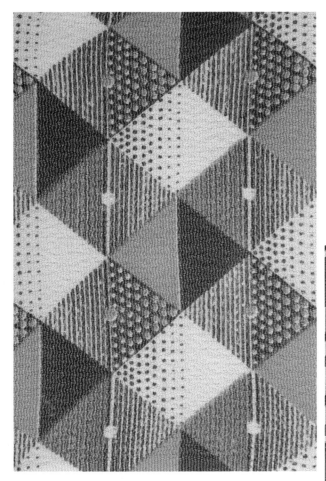

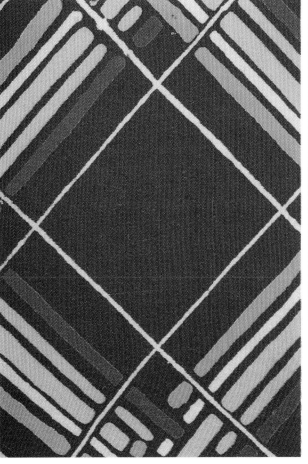

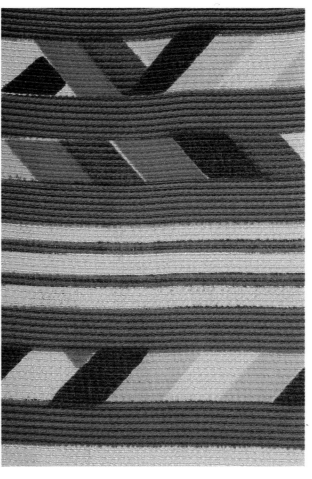

75

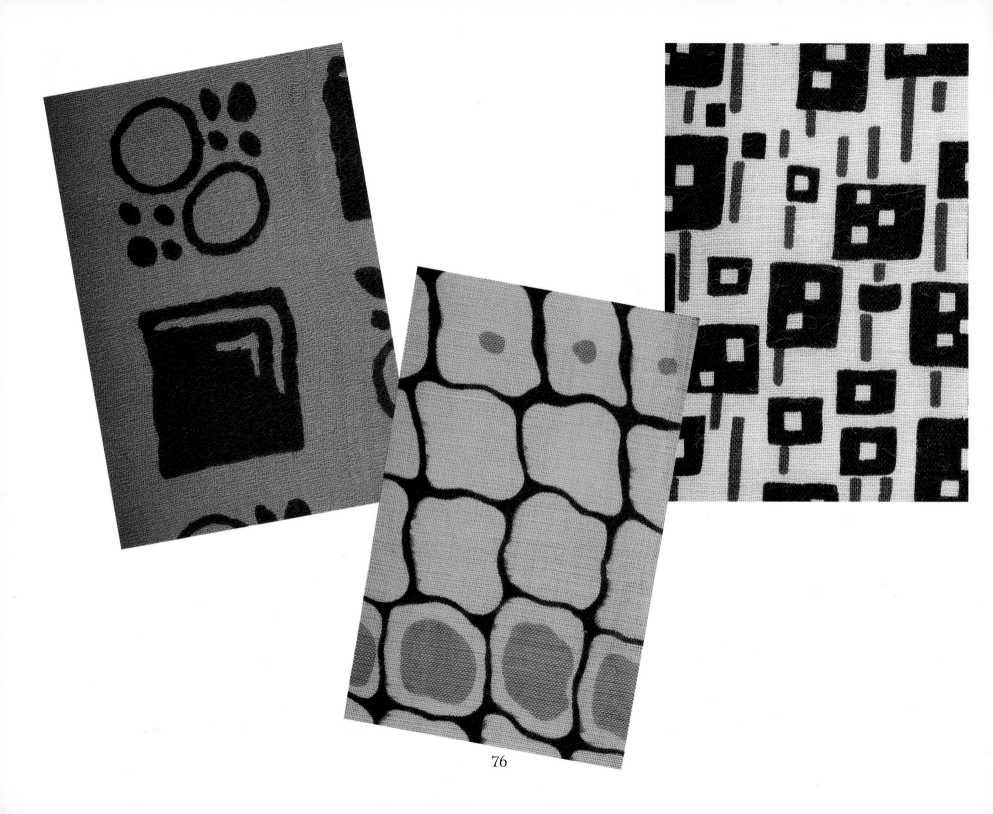

76

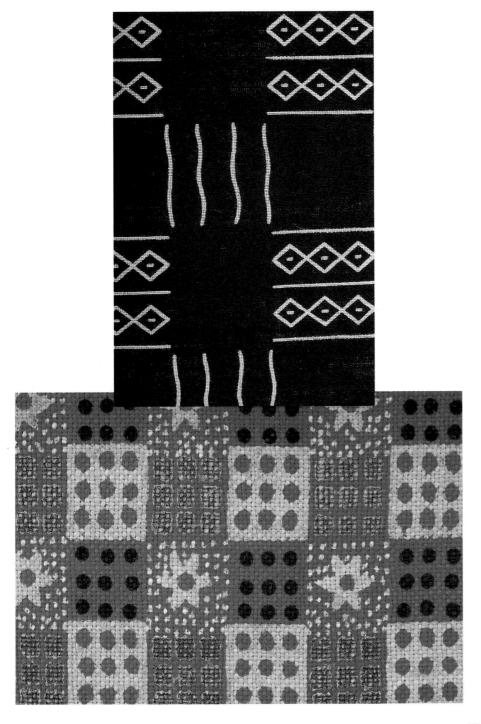

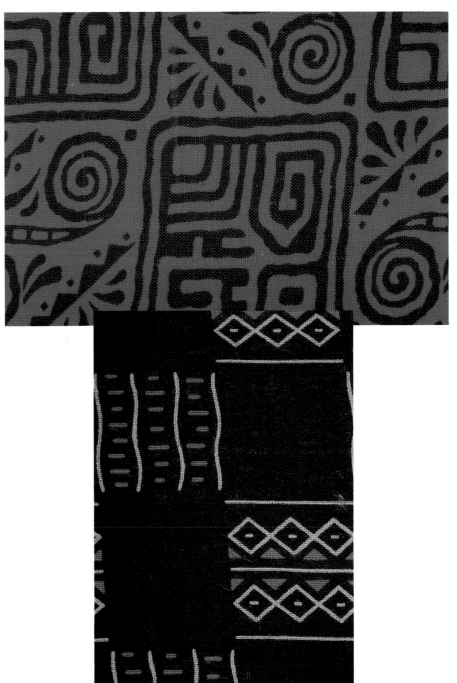

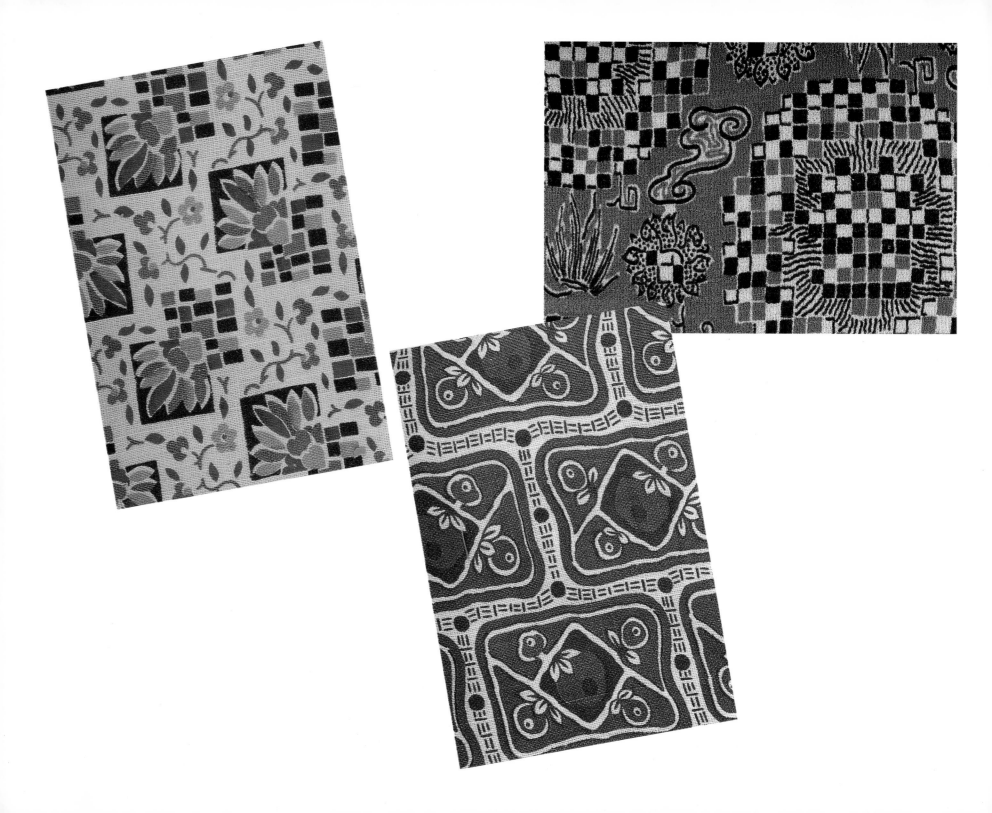

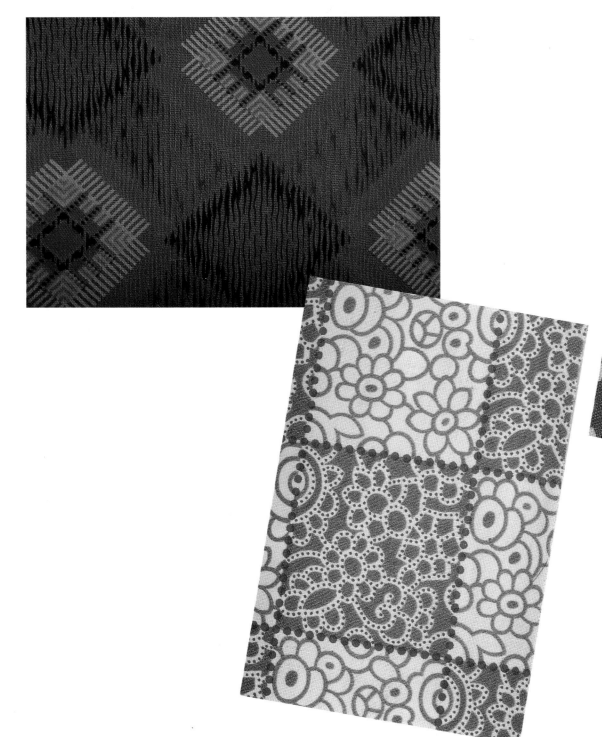
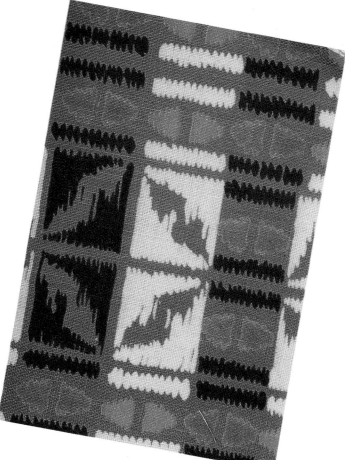

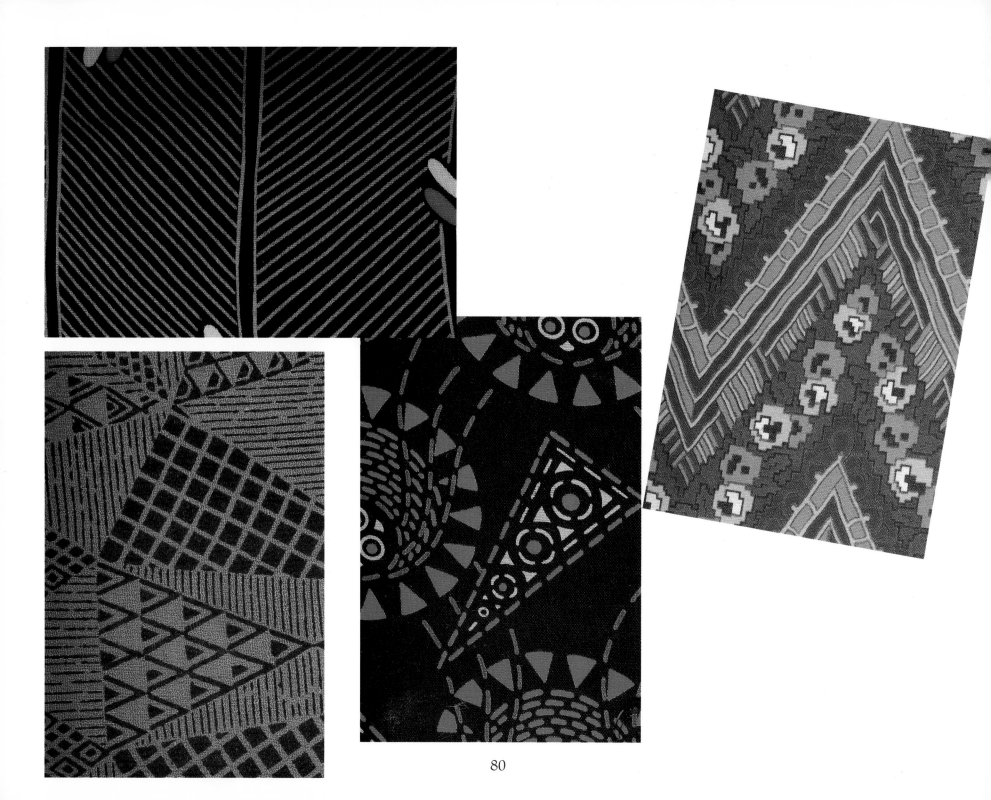

80

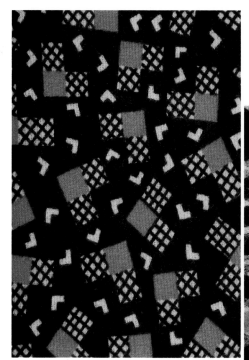
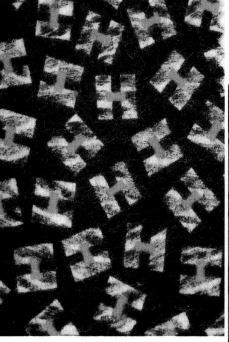
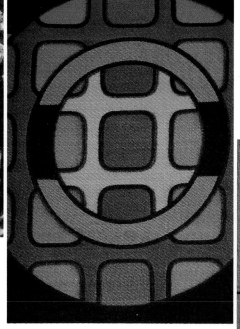
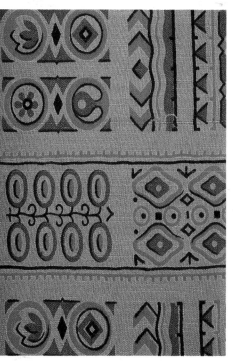

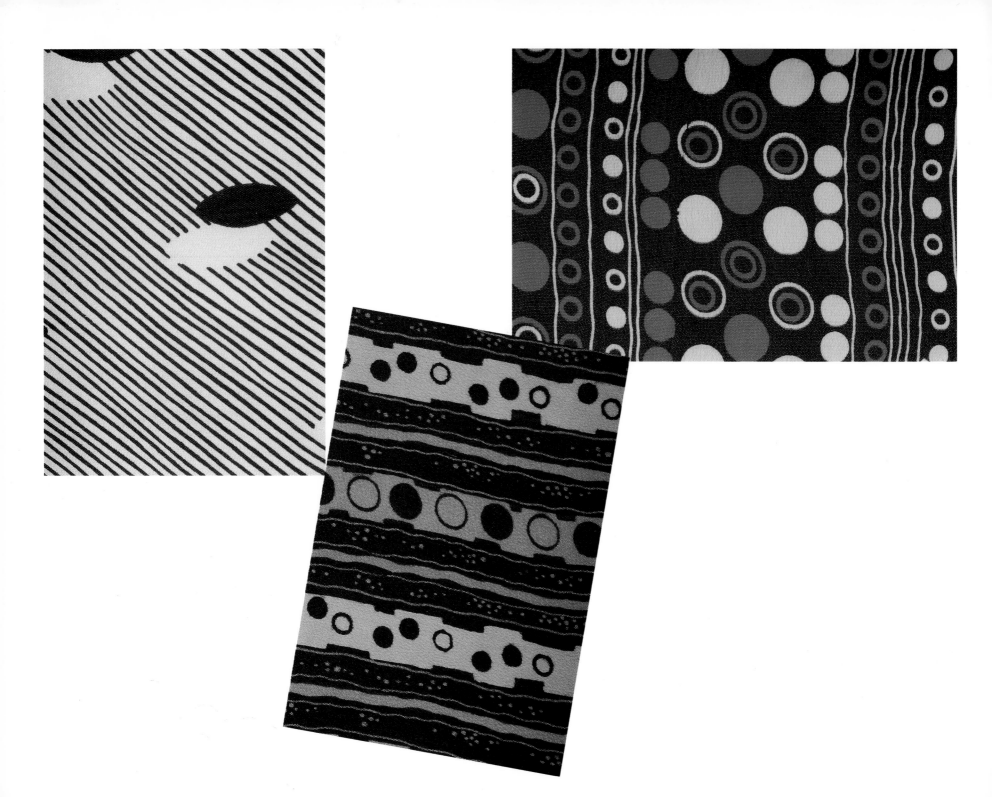

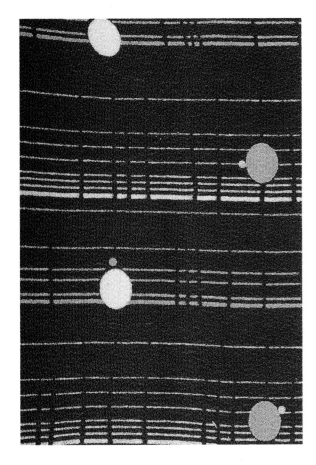

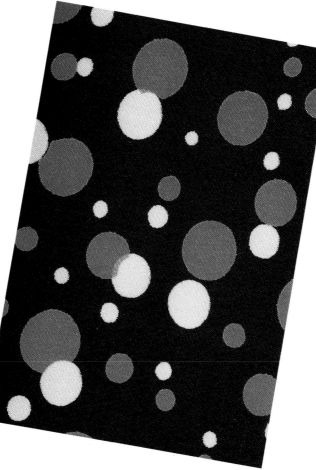

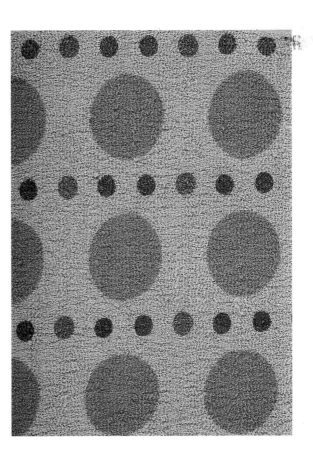

Abstract

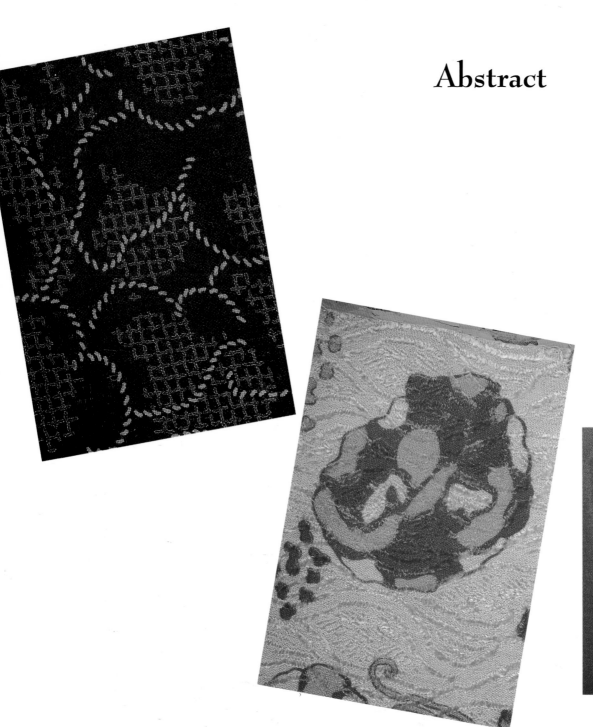

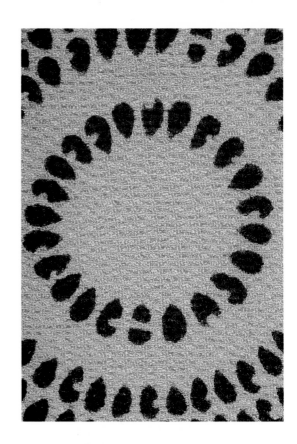

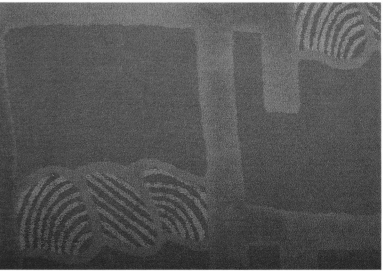

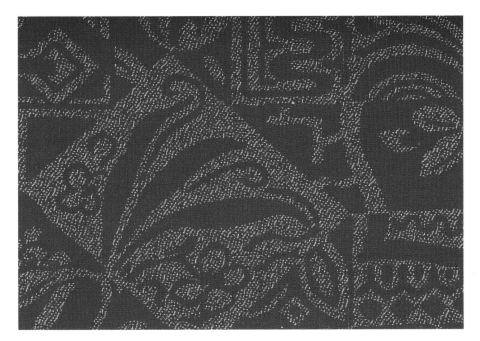

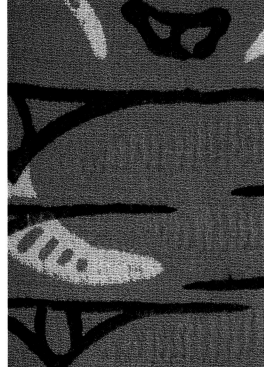

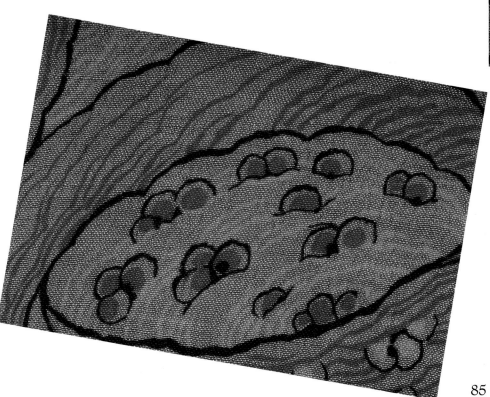

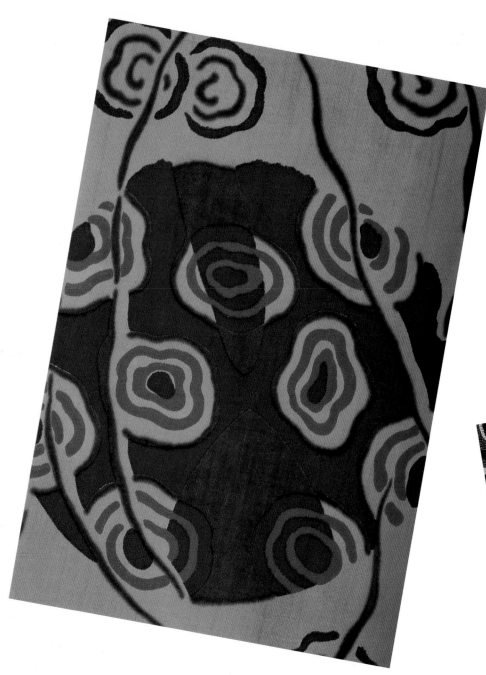

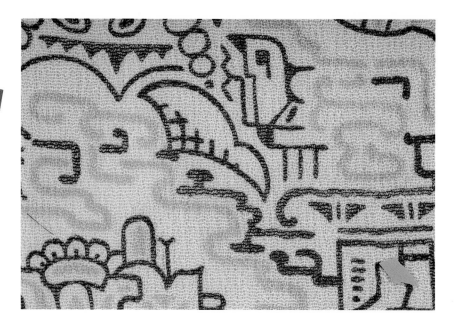

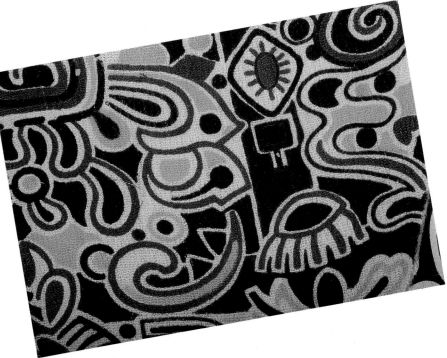

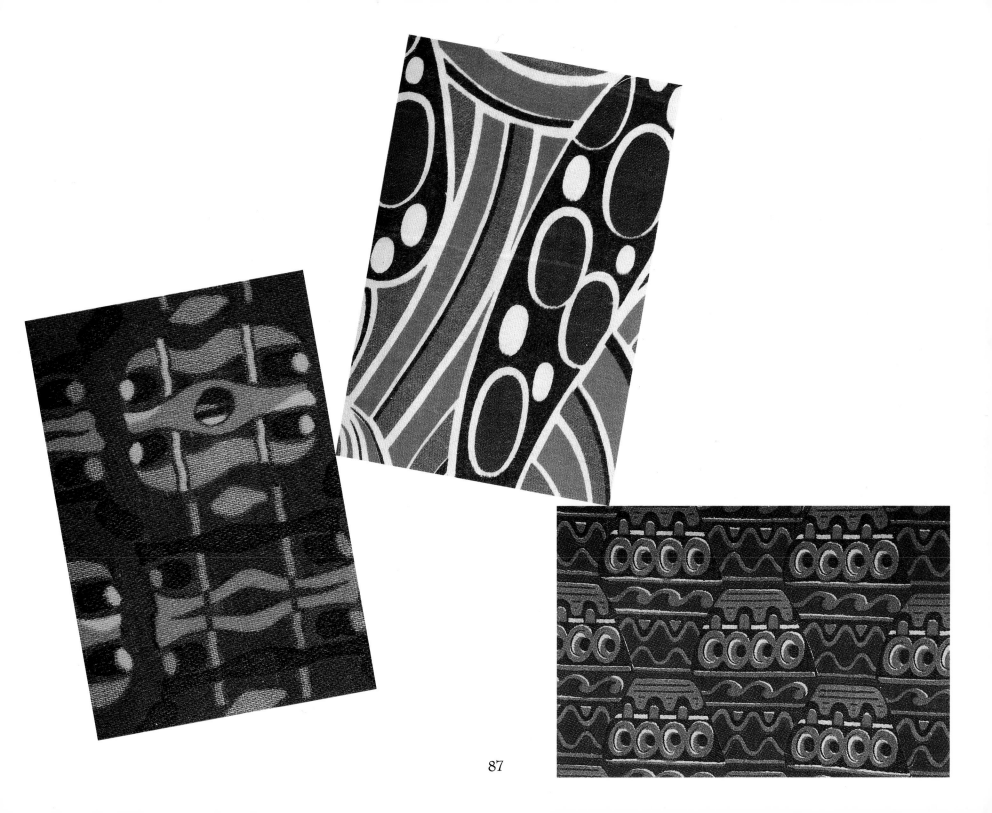

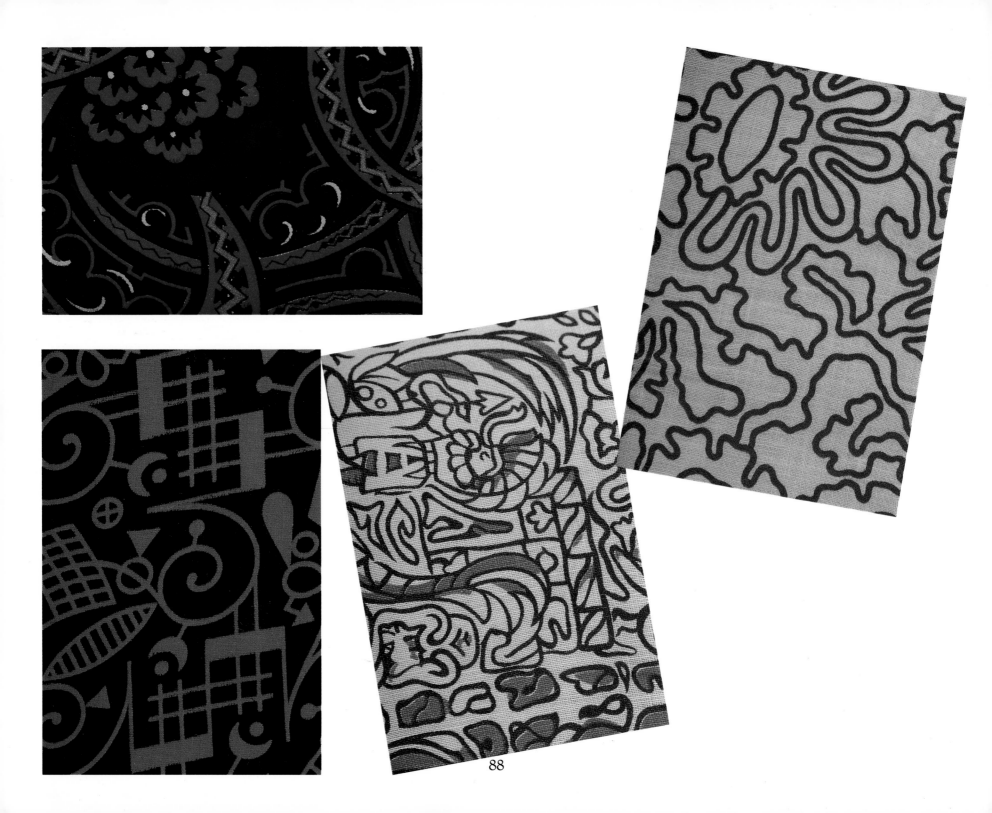

88

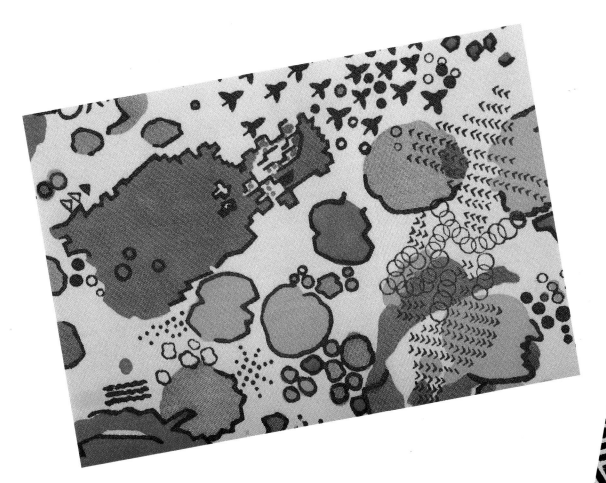

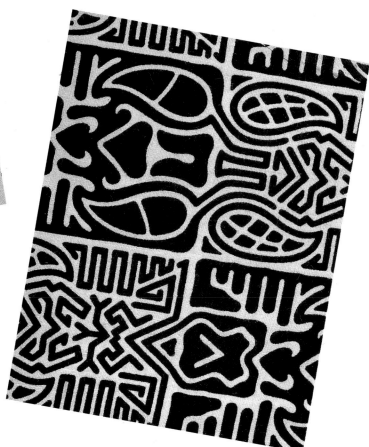

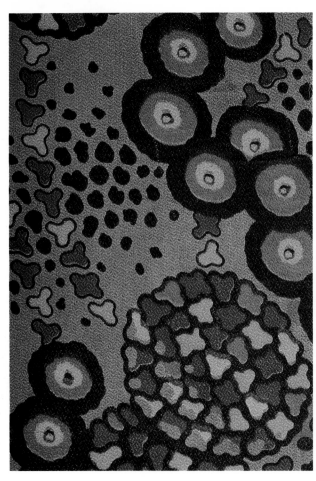
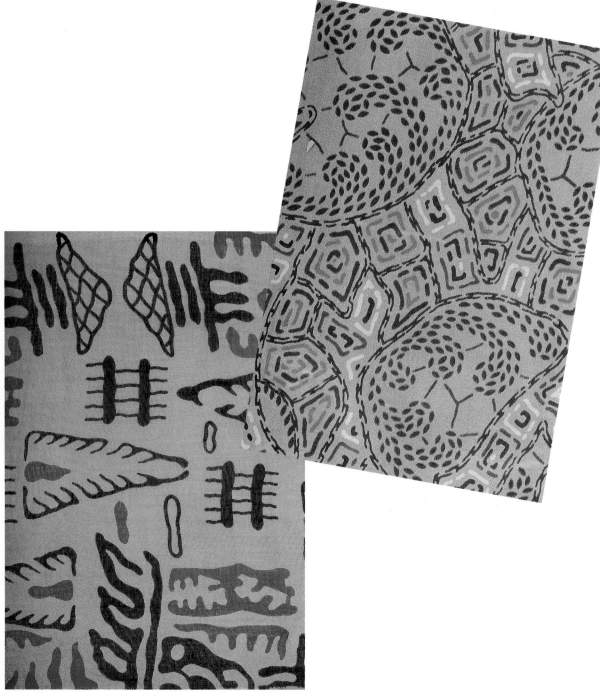

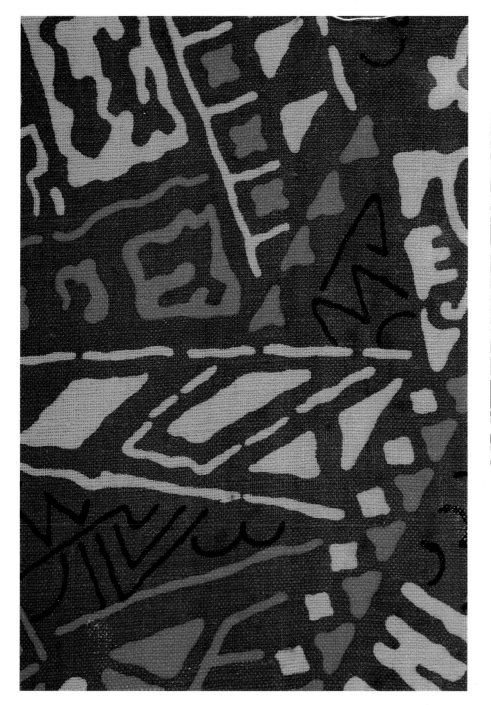

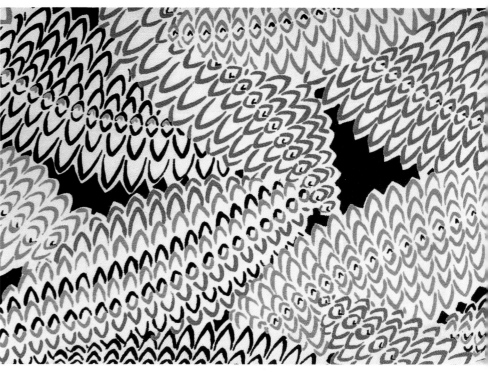

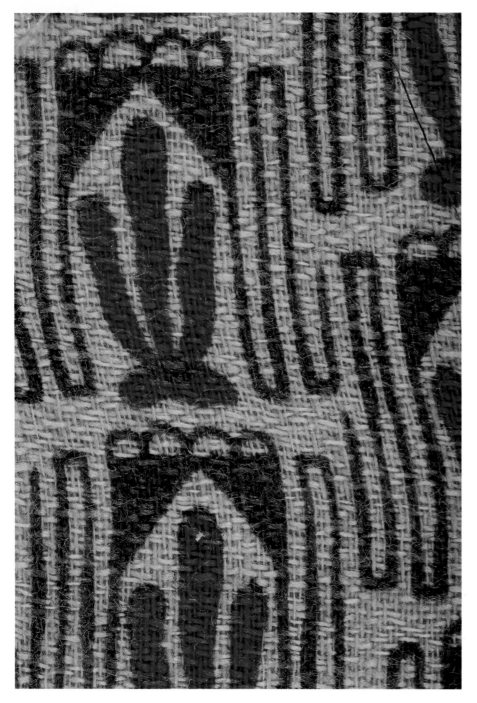

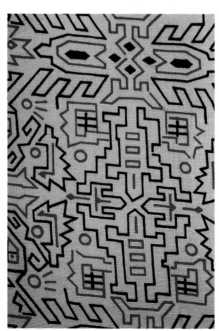

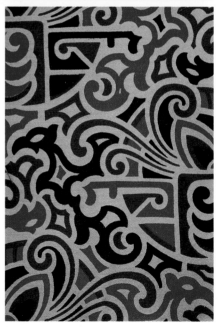

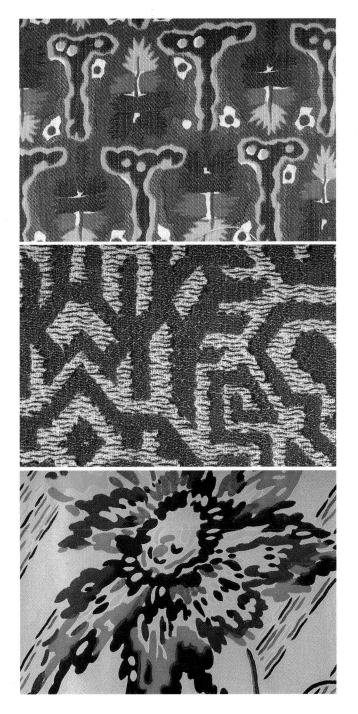

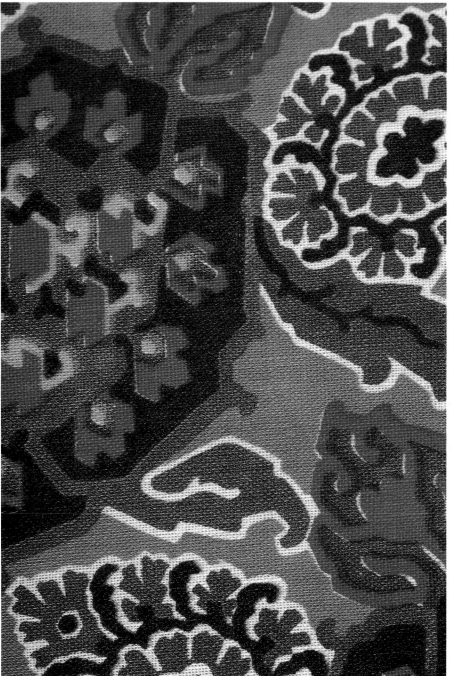

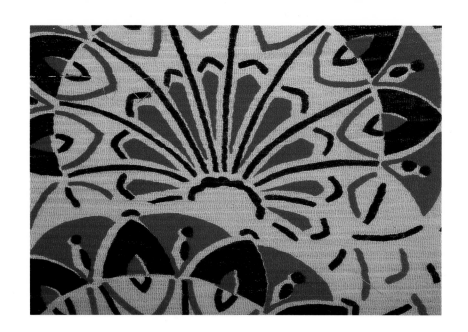

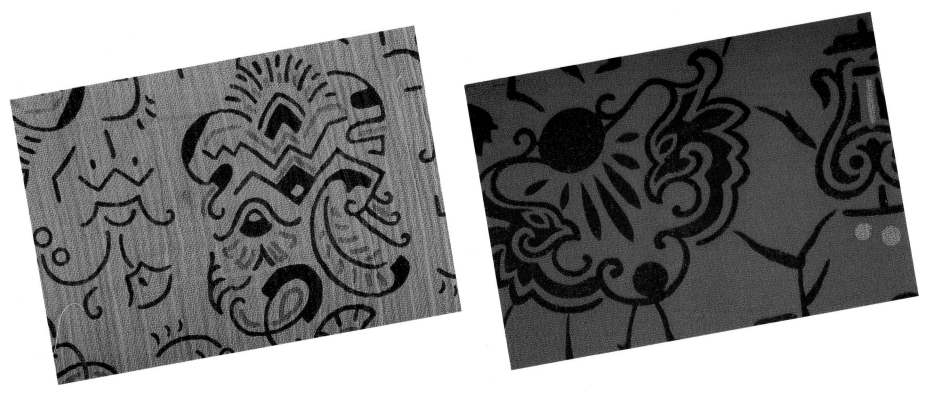

94

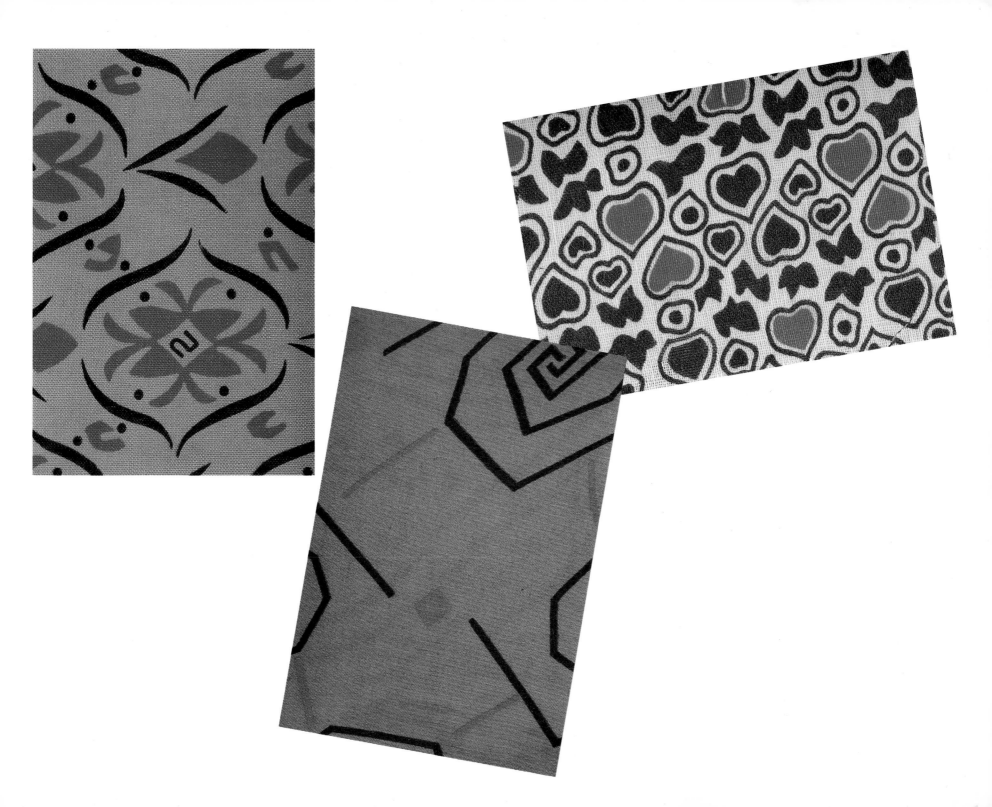

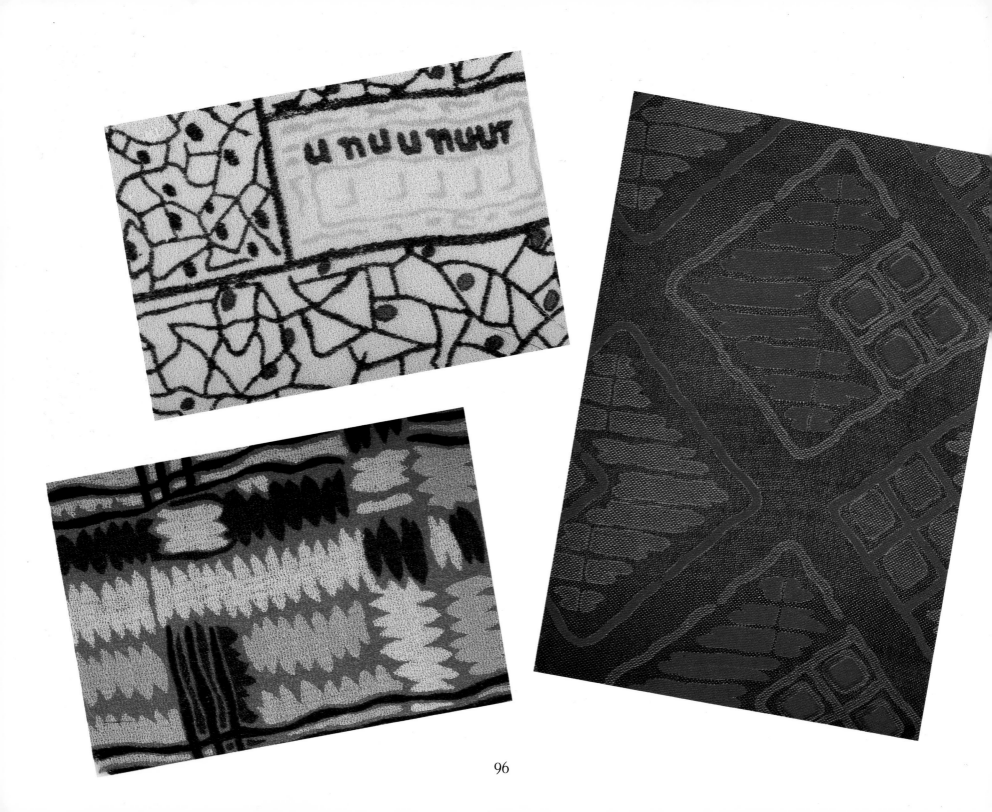

96

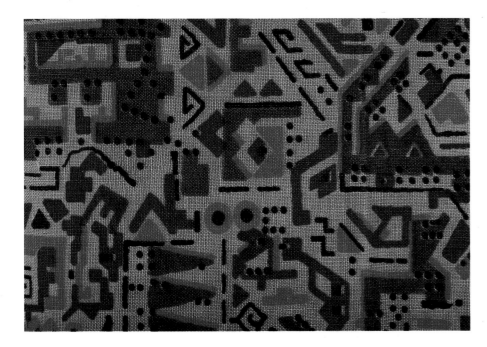

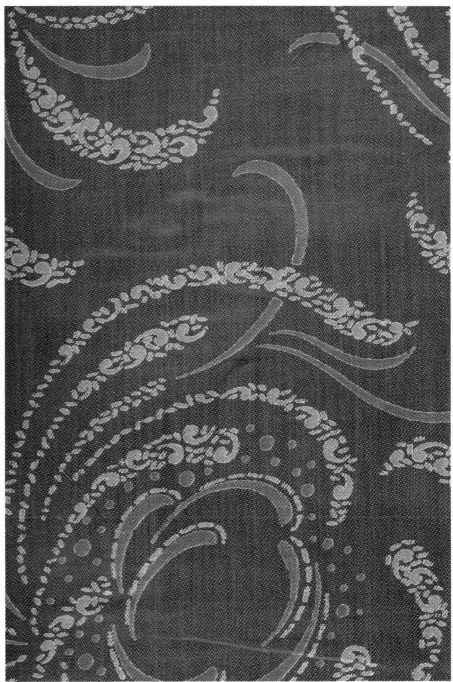

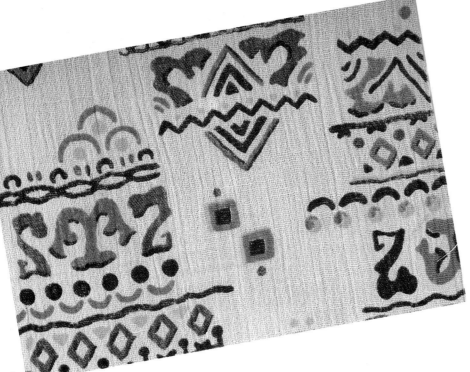

97

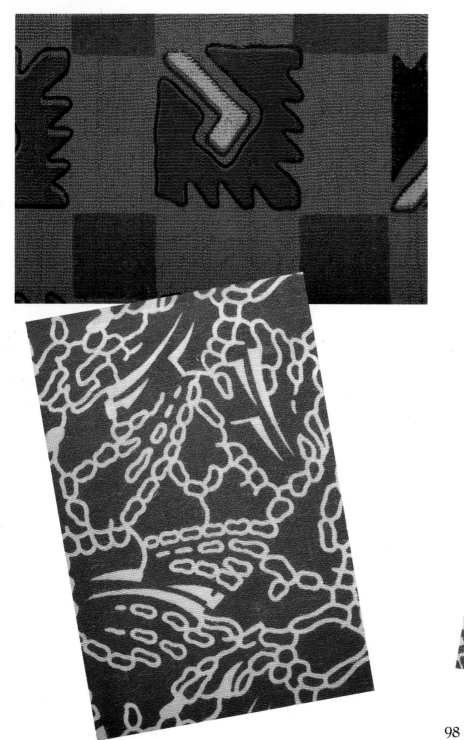
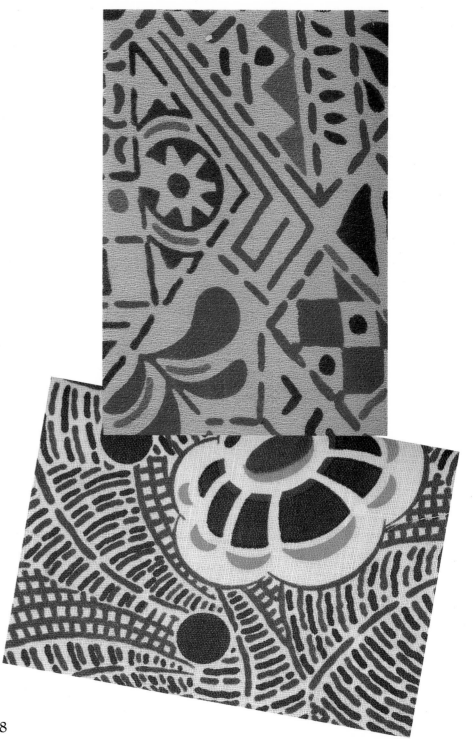

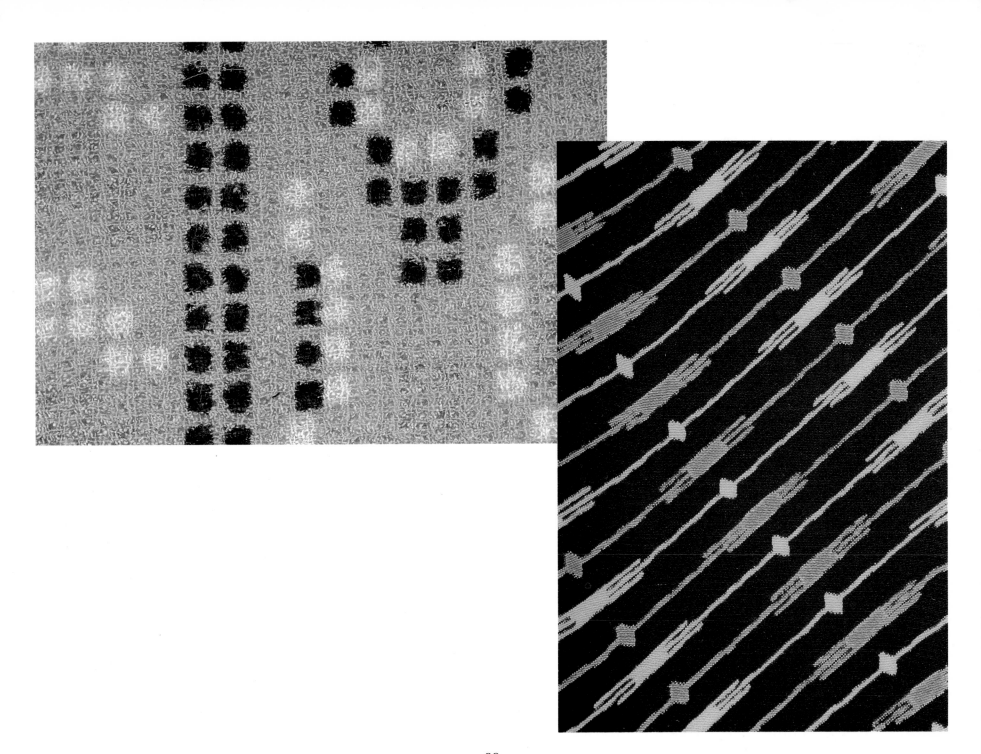

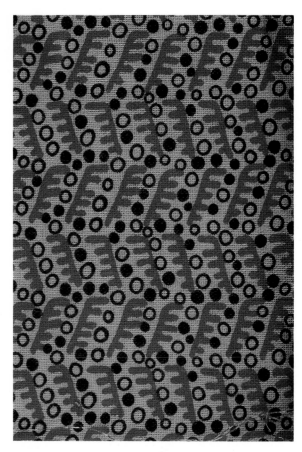

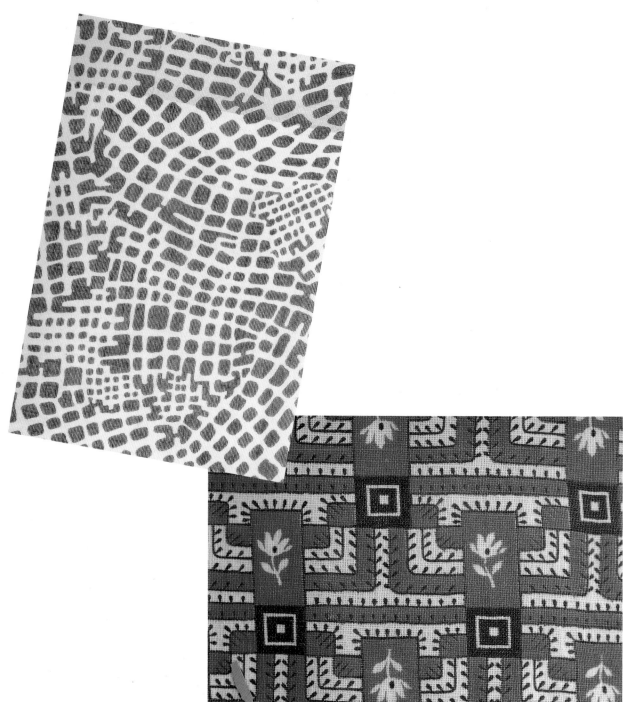

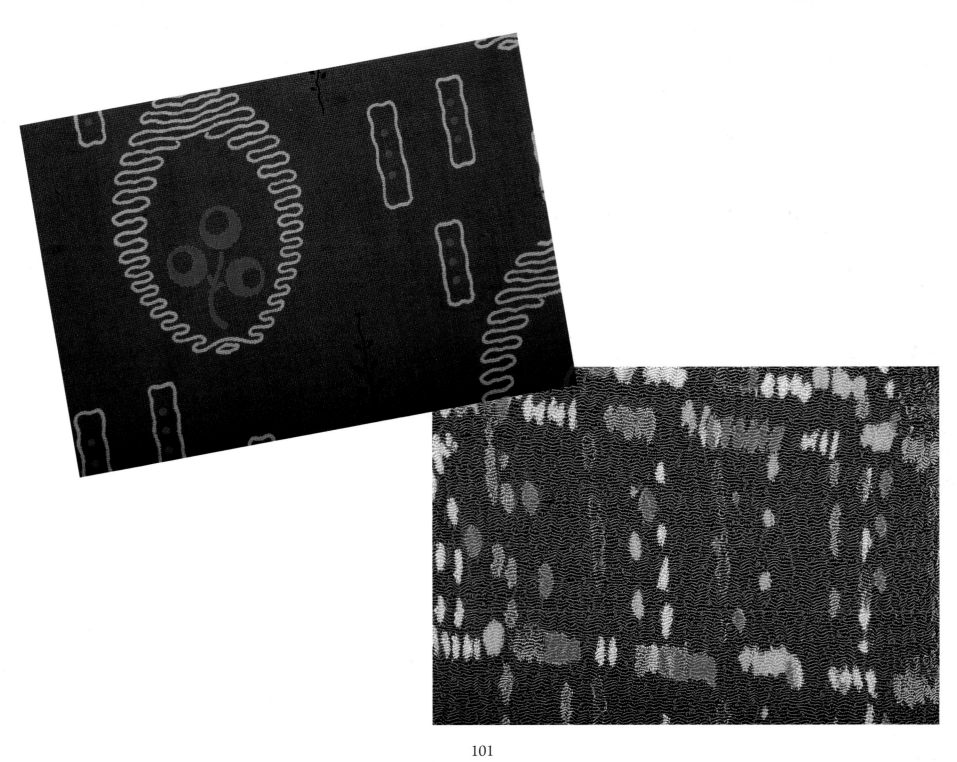

101

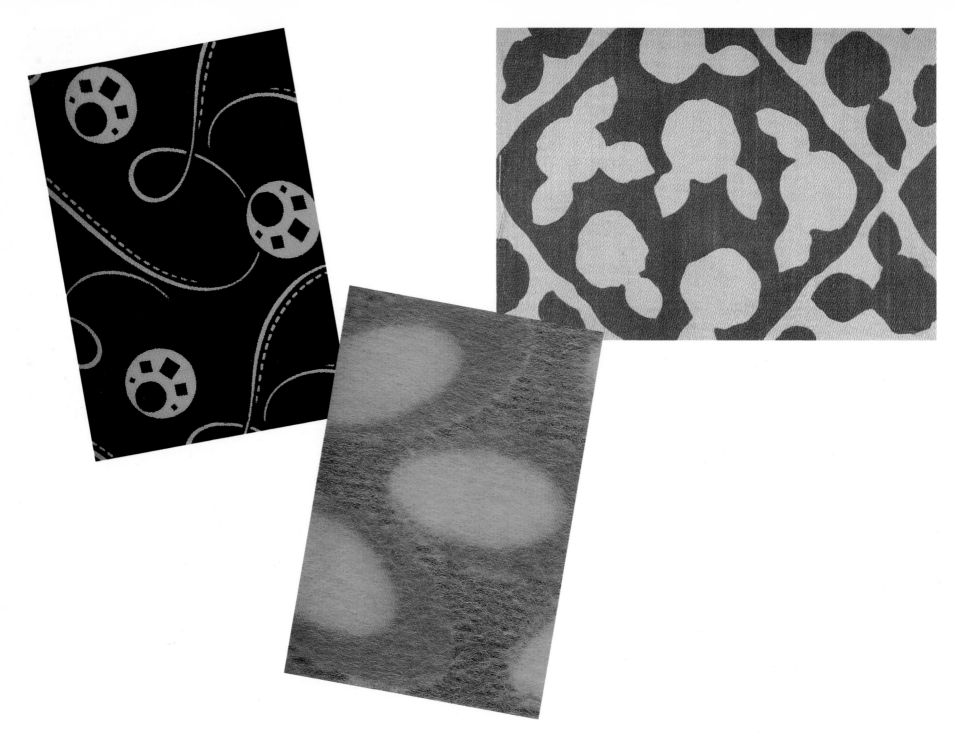

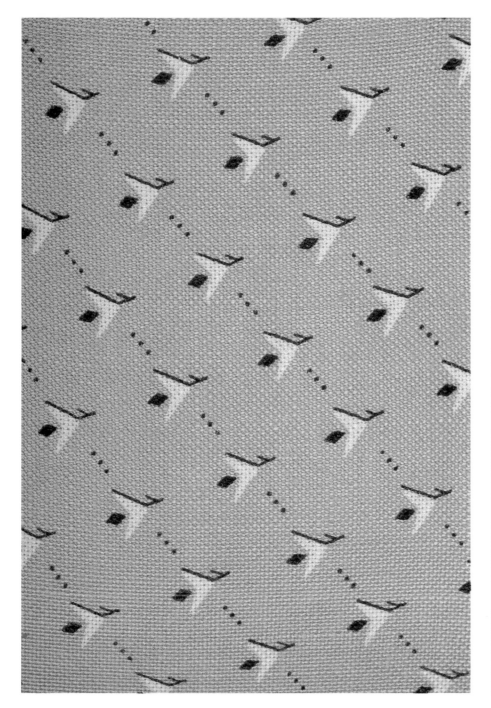
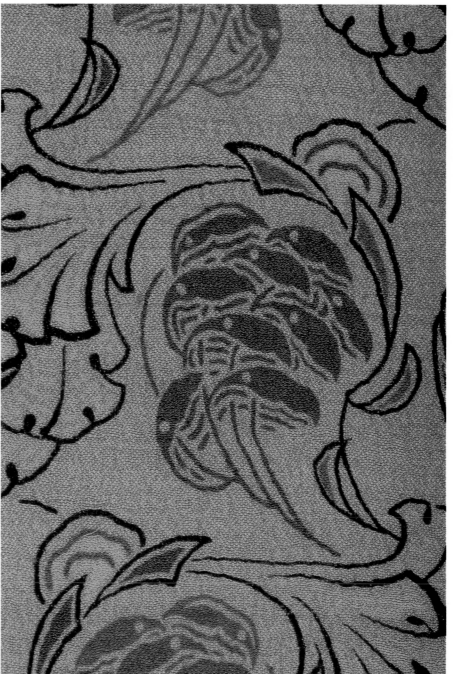

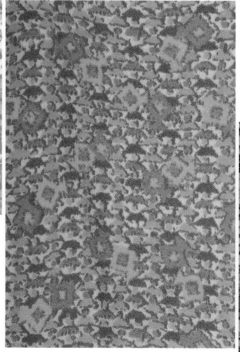

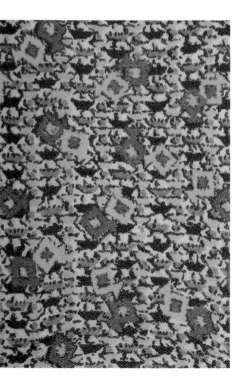

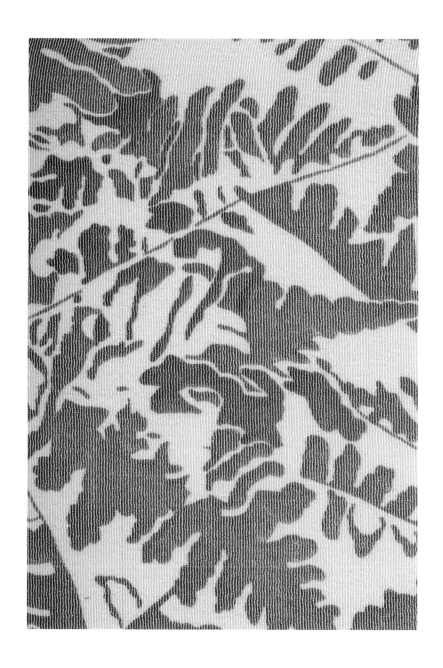

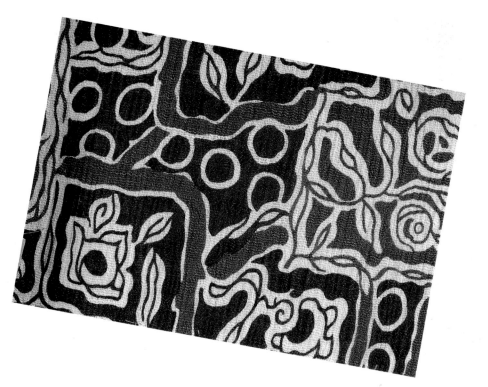

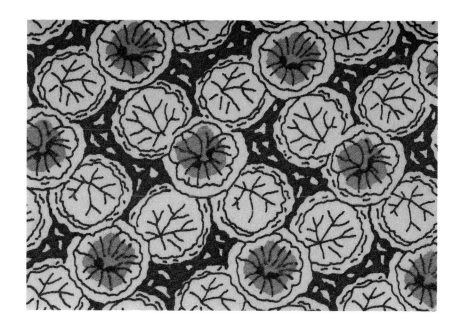

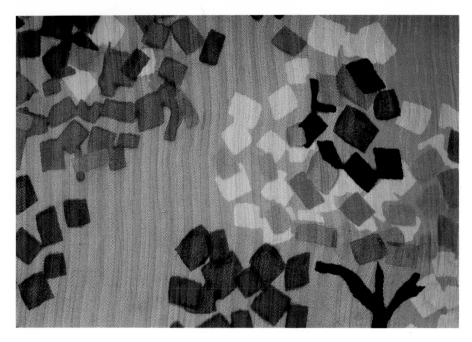

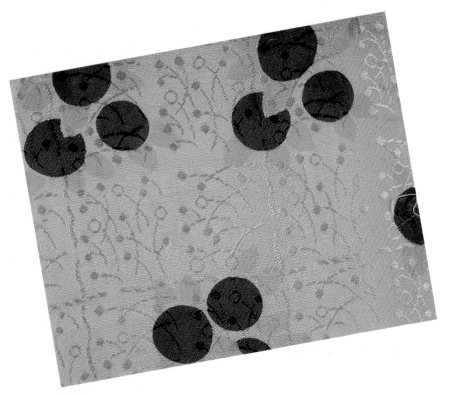

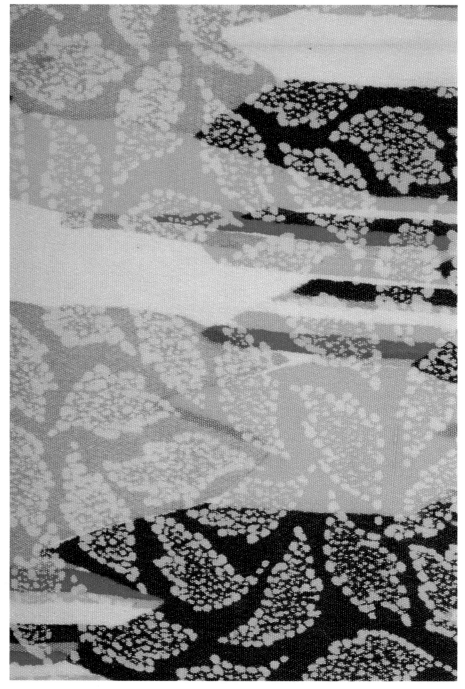

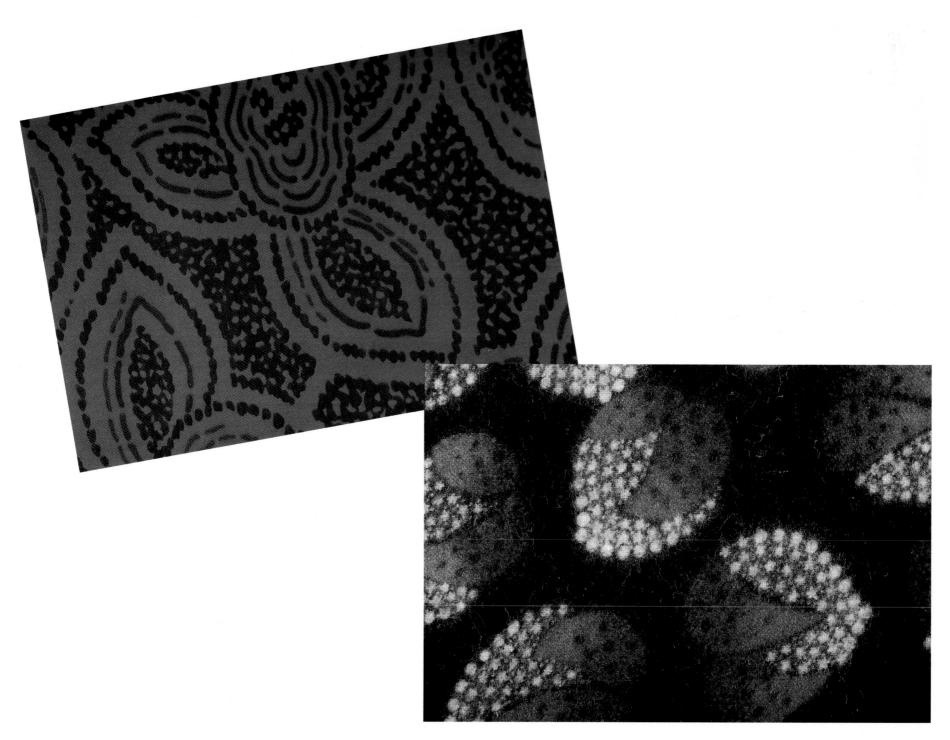

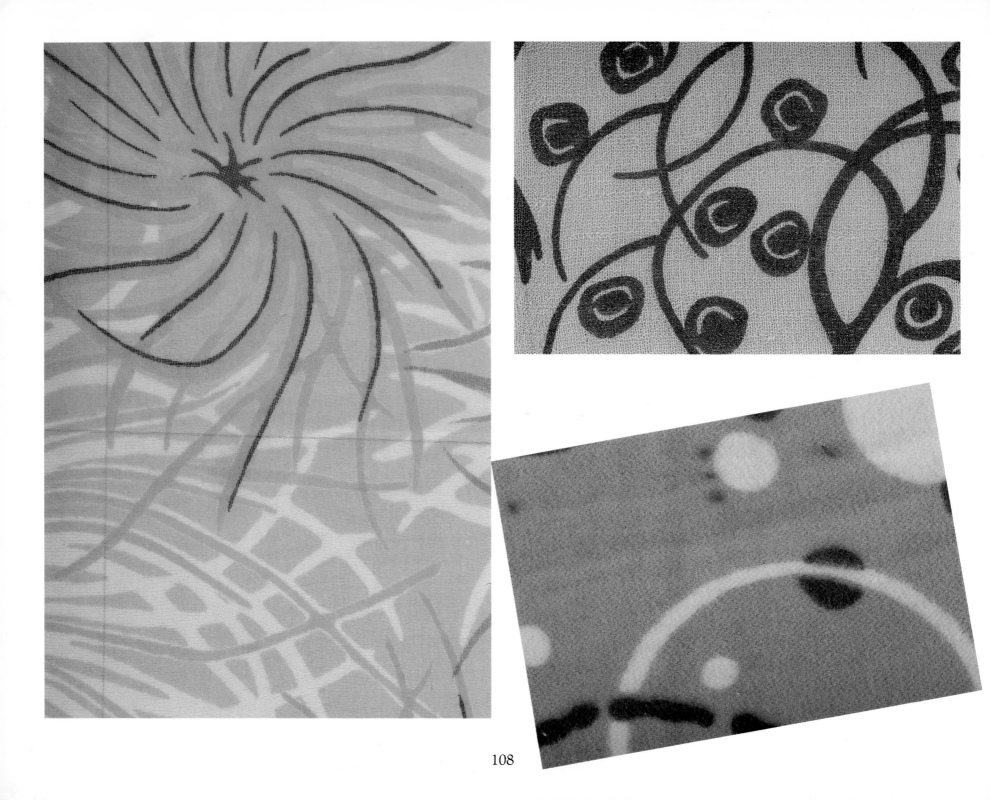

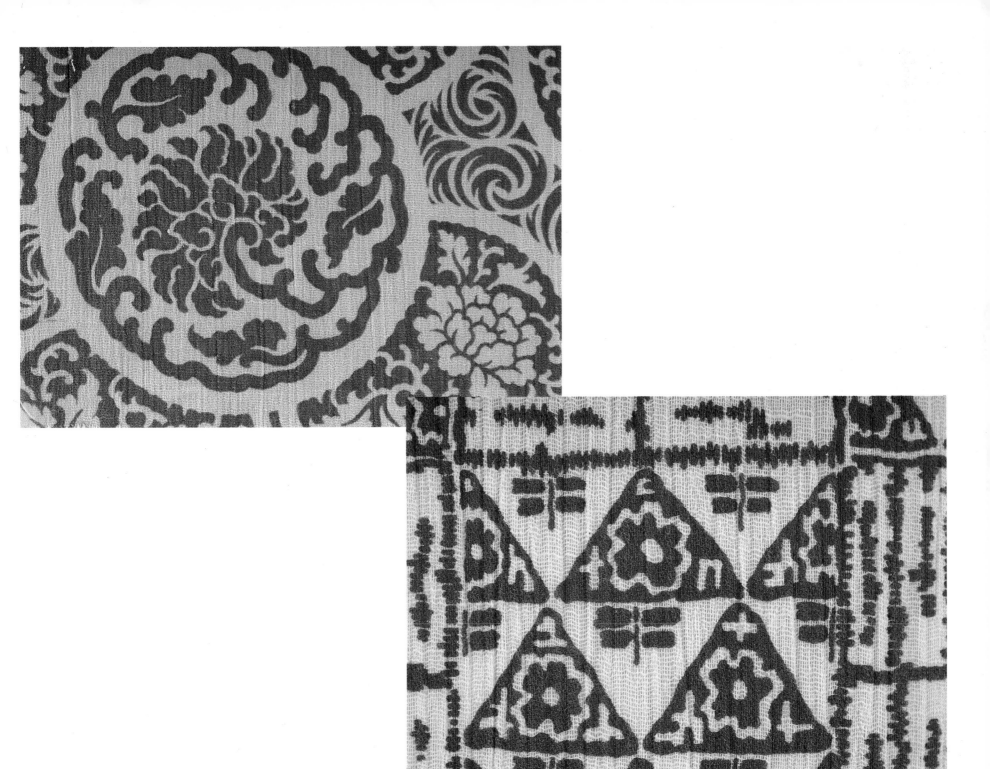

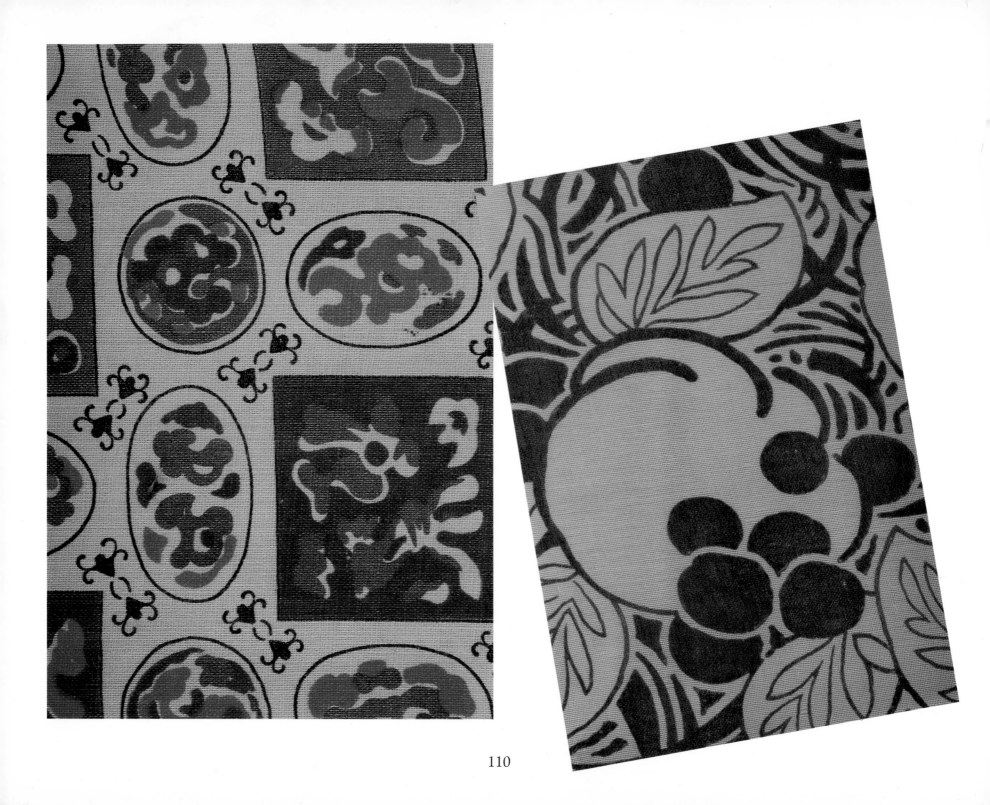

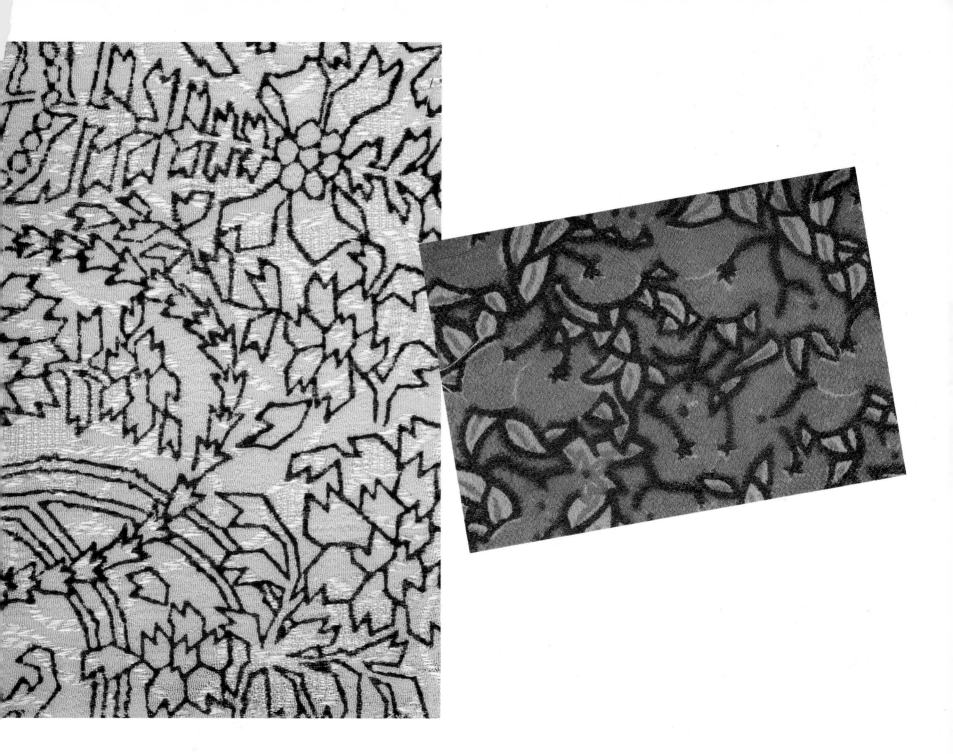

Bibliography

Burbank, Emily. *The Smartly Dressed Woman: How She Does It*. New York: Dodd, Mead and Company, 1925.

Byers, Margaret, and Consuelo Kamholz. *Designing Women: The Art, Technique, and Cost of Being Beautiful*. New York: Simon and Schuster, 1938.

Heide, Robert, and John Gilman. *Popular Art Deco: Depression Era Style and Design*. New York: Abbeville Press, 1991.

Heller, Steven, and Louise Fili. *French Modern*. San Francisco: Chronicle Books.

Jerde, Judith. *Encyclopedia of Textiles*. New York: Facts on File, Inc., 1992.

Meller, Susan. and Joost Elffers, *Textile Designs*. New York: Harry N. Abrams, Inc., 1991.

Sonia Delaunay: Art into Fashion. New York: George Braziller, Inc., 1986.